CRANBROOK
THROUGH TIME
Robert Turcan

AMBERLEY PUBLISHING

Carpe diem (seize the day)
Motto of Horsley Girls House, Cranbrook School.

To Marion, a wonderful grandmother, and all the maids of Cranbrook.

First published 2012

Amberley Publishing
The Hill, Stroud, Gloucestershire, GL5 4EP
www.amberley-books.com

Copyright © Robert Turcan, 2013

The right of Robert Turcan to be identified as the
Author of this work has been asserted in accordance with
the Copyrights, Designs and Patents Act 1988.

ISBN 978 1 4456 0823 5

British Library Cataloguing in Publication Data.
A catalogue record for this book is available from the
British Library.

Typesetting by Amberley Publishing.
Printed in Great Britain.

Introduction

Cranbrook is Kent's smallest town. Its beauty and completeness, however, belies this diminutive status. Uniquely, there are no hideously contemporary developments which mar the overall attractiveness of this town of some 7,000 souls.

Its early origins can be traced back to Roman occupation. The settlement emerged on their road from London to the Sussex coast. Its name is probably derived from where cranes inhabited a brook. Granted a charter for a market in 1290, the town first grew close to important iron-making areas. Extensive forests provided fuel for founding while iron ore was mined locally. The other large-scale Wealden industry was cloth making. Cranbrook was at the centre of this activity, being close to the famous sheep grazing area of Romney Marsh and deposits of fullers earth near Maidstone. Crucial to the emergence of this lucrative business, however, was the settlement of skilled clothiers from the Continent. When Queen Elizabeth I visited the town, it is said that a mile-long length of broadcloth was laid for her procession route. The grey cloth was of such a high quality that it was even used to provide uniforms for Eton school.

Much architectural heritage remains from Cranbrook's golden age – in particular, its flagship building, St Dunstan's church. Its grandeur and size is a reflection of the wealth once created by the wool industry. Clothiers' halls and workers' cottages also remain unspoilt, yet much adapted to current needs. The L-shaped high street is the town's core. Largely comprising period properties, it is renowned for its quaint yet purposeful character. There is a good range of cafés, restaurants and pubs. Specialist shops of the old-fashioned kind abound and all tastes are catered for. Overall, the pretty cottages and elegant houses provide a harmony of styles, colours and architectural variation. Atop all is Cranbrook's emblematic windmill. Much photographed, this working mill is in pristine condition and attracts many visitors.

The ancient grammar school has grown to become a major feature of the town and is now esteemed for its excellence. Agriculture – hop growing in particular – has also played a prominent role in Cranbrook's history. Cranbrook was the epicentre of acres of hop gardens and the many surviving oast houses bear testament to the intensity of this farming practice. To a lesser degree, Kent's famous fruit orchards are dotted around the lovely surrounding countryside.

Here, among the fabulous forest of Bedgebury and alongside the artificially created water reservoir of Bewl Water, a number of handsome stately homes can be found. Some of these, like Hempsted House, have been converted to schools such as Benenden.

Indeed, it is not hard to imagine why Cranbrook attracted a colony of artists in mid-Victorian times. The town was also known for its adherents to nonconformist religions and their varied chapels. Today, the well cared for gardens and thriving community organisations are evidence of a strong cohesive society. Time has been kind to Cranbrook, especially because it is not on a rail line and the main highway passes it by. The old and new images in these pages reveal how crowded the streets have become with the advent of motor transport. Nonetheless, Cranbrook continues to be a picturesque and magnificent jewel of the Kentish Weald.

The Union Windmill

Built in 1814, the Union Windmill has been described as 'possibly the finest windmill in the land'. This Grade I listed building is maintained in full working order and ably managed by a dedicated team of volunteers. Whenever there is sufficient wind and it is open to the public, it is possible to watch its wooden cogs and stone wheels grind wheat into wholemeal flour for sale.

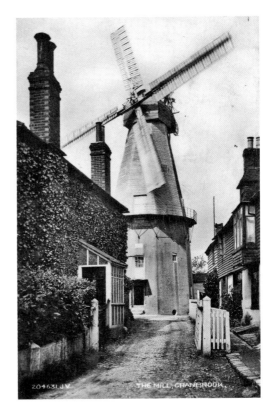

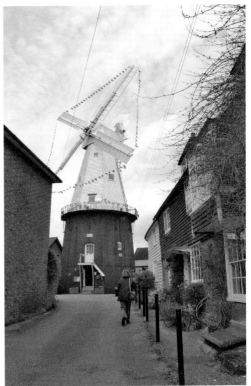

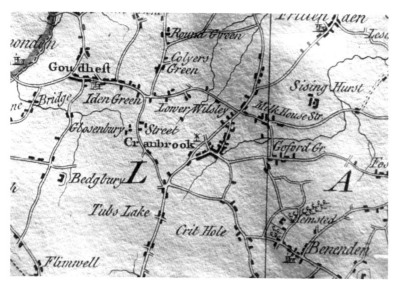

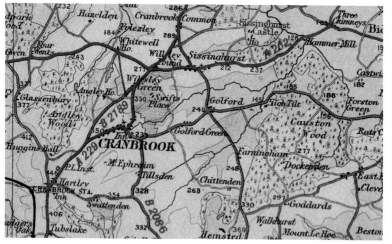

Cranbrook's Development I
The 1794 map depicts Cranbrook as a small town, established along the main thoroughfare. The railway came late to the town, just before the turn of the nineteenth century. In the extreme bottom left of the middle map, the station is annotated. This closed, however, as it was a victim of Lord Beeching's cuts in the 1960s. The bottom map shows post-war housing developments to the east and south.

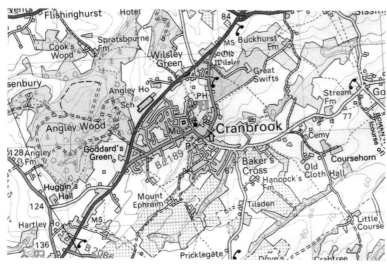

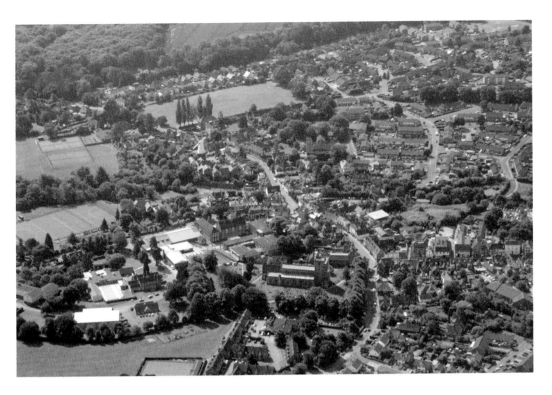

Cranbrook's Development II

These aerial photographs were taken at the height of a July heatwave. In the top shot, looking south-east, Cranbrook's most recognisable buildings – its windmill and St Dunstan's church – are visible. The photograph below, looking north-west, shows the town's old main roads enclosing later streets of housing.

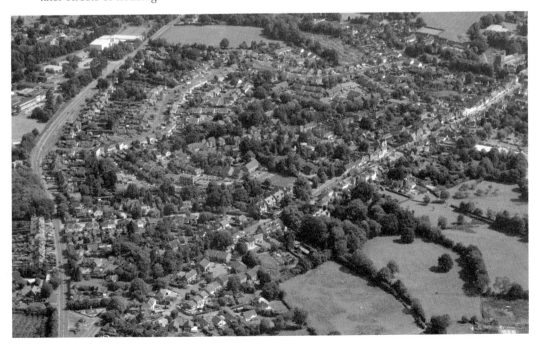

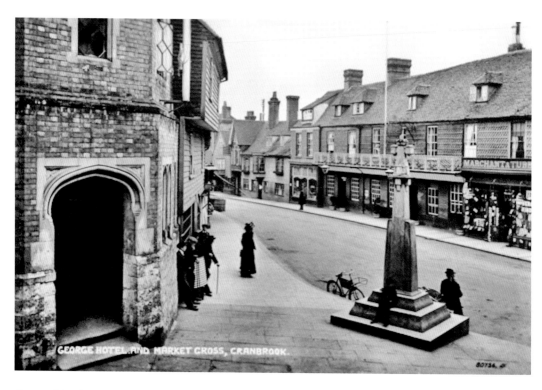

George Hotel I

Dating to 1300, the George Hotel in Stone Street, is one of Cranbrook's most historic buildings, which played host to Queen Elizabeth I in 1573.

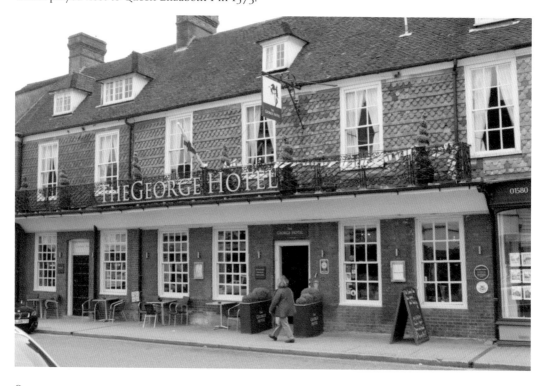

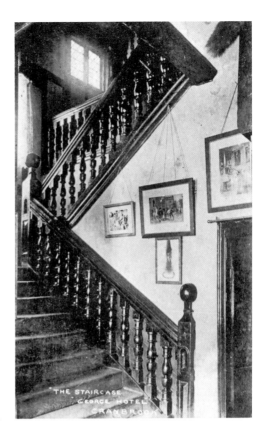

George Hotel II
This magnificent staircase is flanked by
two full suits of armour. It leads to twelve
comfortable, well-appointed rooms for visitors.

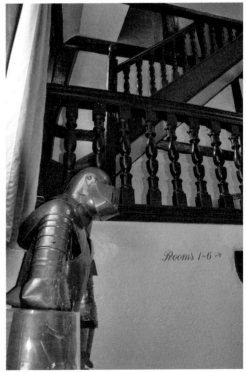

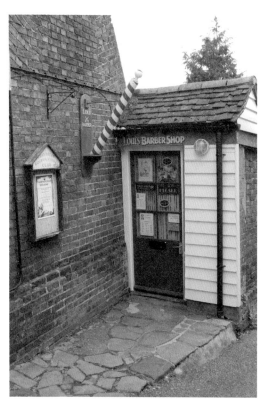

'Confined Spaces'

The jaunty entrance to Louis Barber's Shop instantly invites photographers' attention due to its compactness. However, the old town lock-up below must have felt rather confined if shared with other prisoners. It measures only 8 feet by 6 feet and stands preserved in the town's museum gardens. Originally sited near St David's Bridge, the old oak structure was moved to Wilsley Farm and then Wilsley House before restoration.

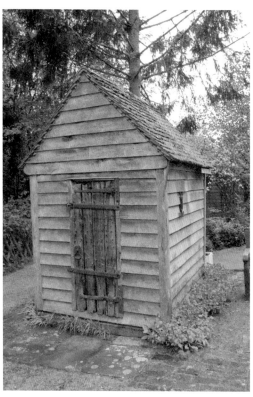

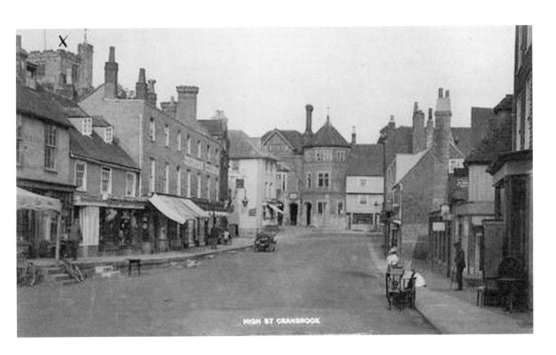

Lower High Street I
One lonely car and handcart serve to remind us how empty the Lower High Street was before motoring became more popular in the 1920s. Today, however, there is always a presence of at least parked vehicles.

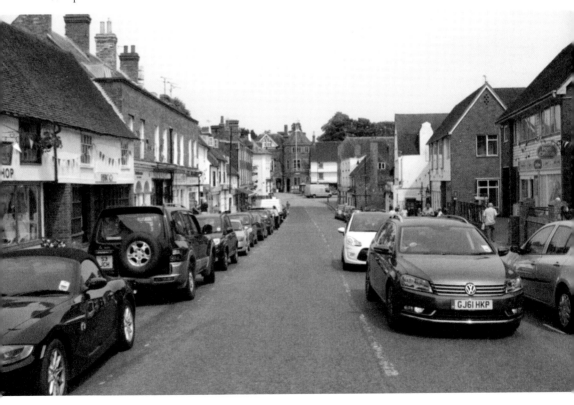

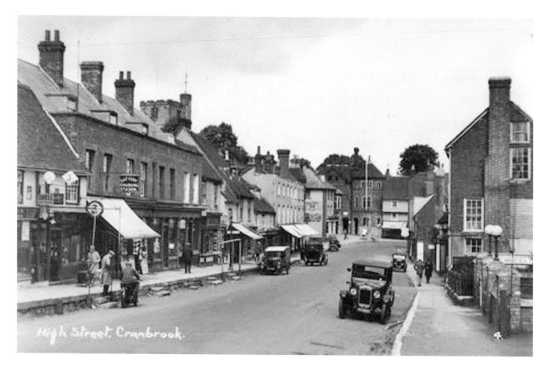

Lower High Street II

Double yellow lines now serve to prevent congestion at the vital right-hand bend of the Lower High Street. However, planners have been wise to preserve some street parking, for in rural areas casual shoppers have always needed handy places to stop off.

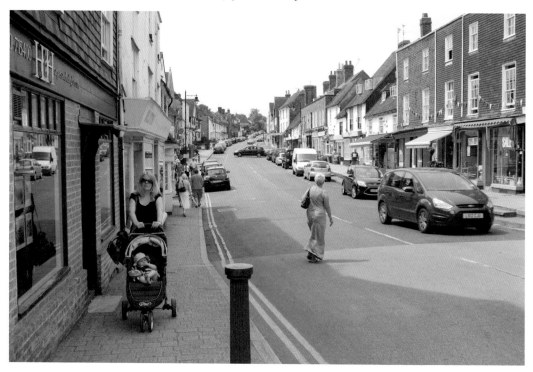

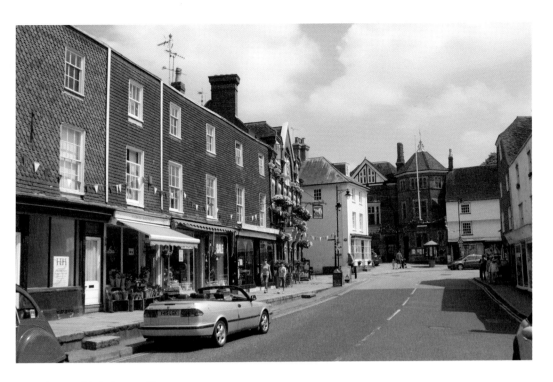

Lower High Street III

The White Horse pub at the bottom of Lower High Street is festooned during summer months with a fine display of blooming flowers. Its unusual architecture includes an embossed panel of Kent's White Horse Invicta emblem. Cranbrook once boasted a total of some twenty-four inns and beerhouses.

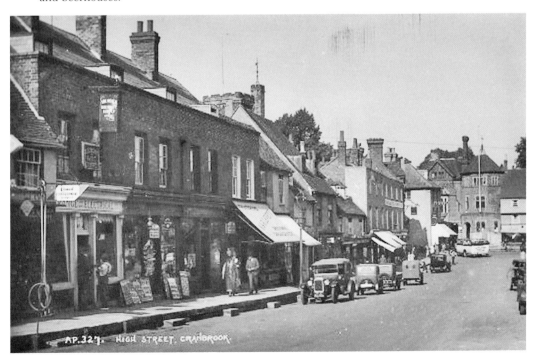

Market Cross

Recognising Cranbrook's growing importance, Edward I granted the right to hold a market. The lower part of the column of the original market cross (albeit adapted to a sundial) is preserved in the grounds of the museum. Little has changed at this corner of the town, except that contemporary children's clothing is far less formal.

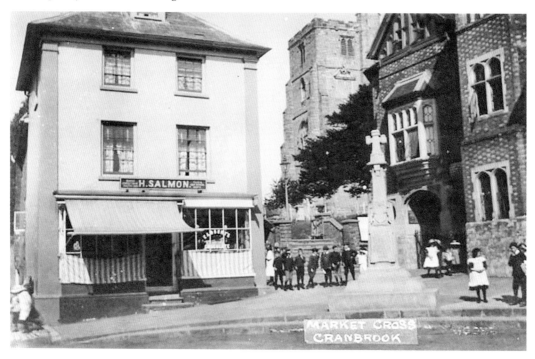

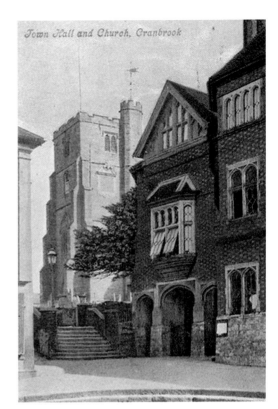

Town Hall and Church, Cranbrook

Vestry Hall and Old Fire Station
The Vestry Hall depicted here is home to
Cranbrook Parish Council and Wealden
Visitor Centre. Its handsome neo-Tudor
style incorporates stone facings and
chequered brickwork. Always keen to
promote the prosperity of the town, the
parish council uses the roundel display
cabinet to report its activities to passers-by.

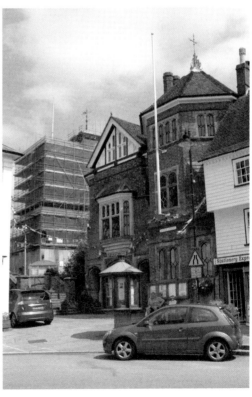

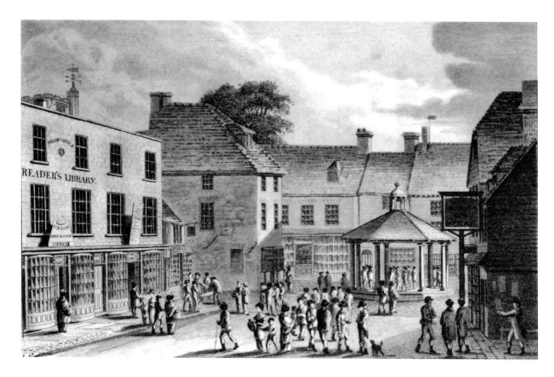

Market House

The early print above illustrates the long gone market house. It was a neat octagonal building supported on double columns at the angles, and surmounted by a cupola. William Coleman Esq., a great benefactor to the town, paid for its erection in 1831. The snapshot below shows this area today choked with traffic.

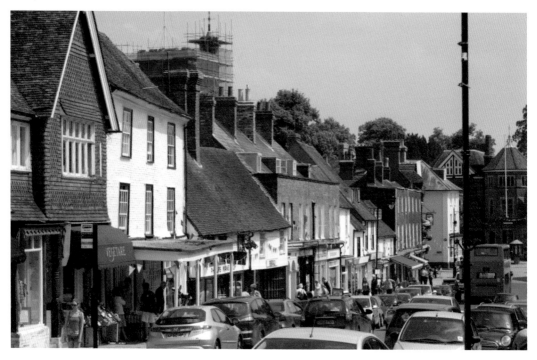

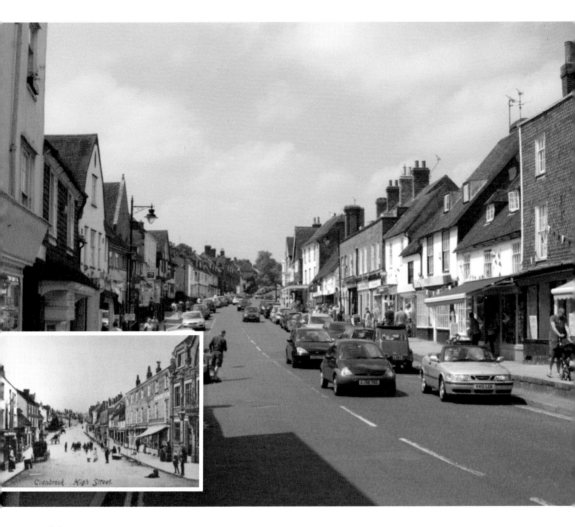

High Street

The main High Street is some three quarters of a mile long and gradually changes from shops and commercial premises to lovely terraced period cottages and fine detached houses towards its western end. Unlike many modern high streets, shops still have awnings overhanging pavements.

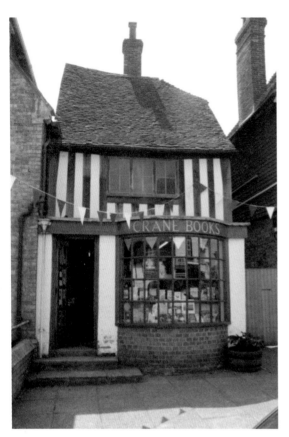

Half-Timbered Buildings

Not all of Cranbrook's half-timbered buildings are original, like the inviting Crane Books seen on the left. Lloyds Bank is a good facsimile of a timber-framed Tudor building. So proud was this bank of their Cranbrook branch that for a while its façade featured boldly in their national newspaper advertising campaign. Fortunately, its precise construction and uniformity prevent it from looking like a pastiche, so it harmonises rather than clashes with its neighbouring buildings.

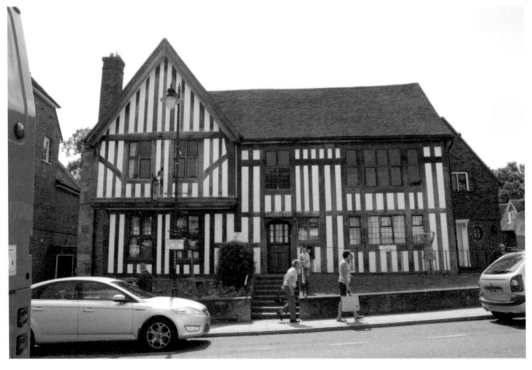

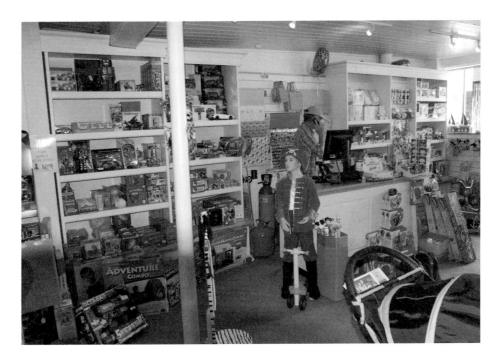

Colourful Shops

The picture above illustrates a corner of Alfie and Daisy, the magical toyshop in Stone Street. It is a magnet for 'children' of all ages with its exciting range of tradition wooden toys and board games. Its proprietor, seen engaged on the telephone, is enthusiastic about his business, named after his own two children. Below is a snapshot taken in a specialist children's clothes shop in the High Street. Similarly, the well chosen quality merchandise attracts curiosity and thus custom.

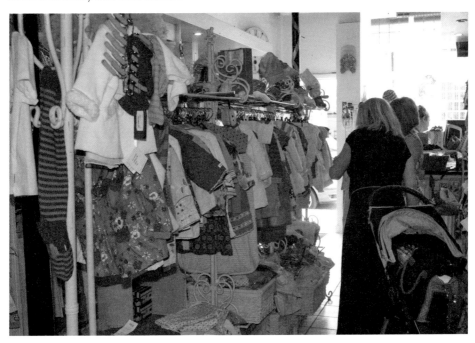

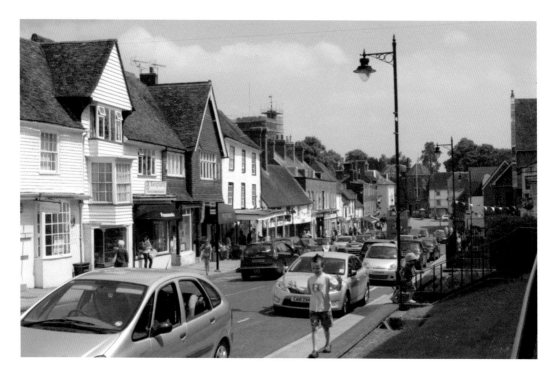

Mid High Street

Little change has taken place over a century in the mid-High Street, except for the impact of cars rather than horse-drawn vehicles. The church tower of St Dunstan's and the vestry tower still stand sentinel over a healthy bustling shopping precinct.

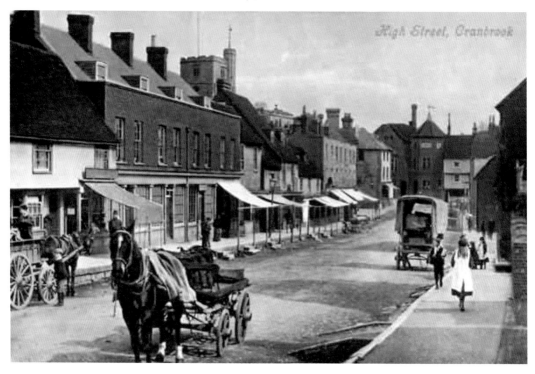

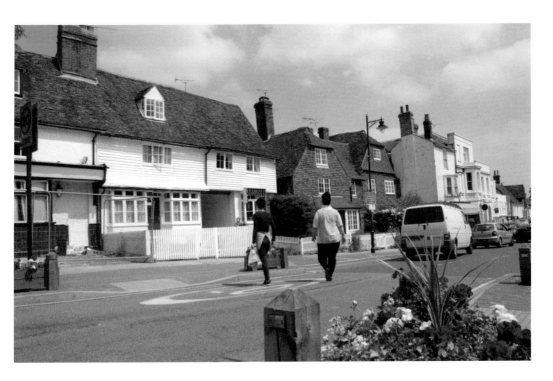

Upper High Street

As the long High Street continues westward, shops gradually give way to beautiful white weatherboarded or peg tile hung cottages. The long traditional wooden picket fences continue to enhance the scene. Road markings now inevitably detract, but this is more than compensated for by tubs of blooming plants.

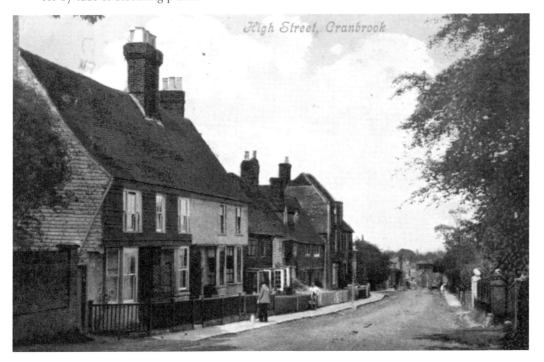

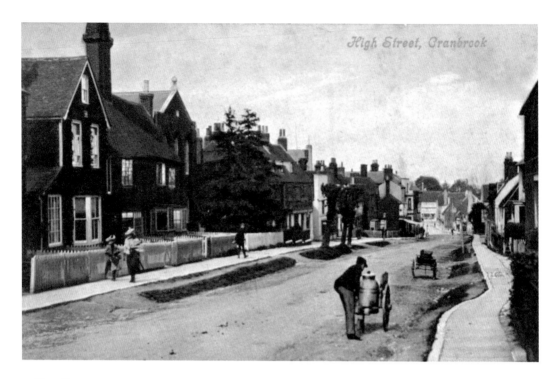

Milk Delivery

The postcard image above is of a lost age when milk was delivered to homes in a wheeled churn handcart. Below, a village atmosphere still remains, but all vestiges of grass verges have disappeared.

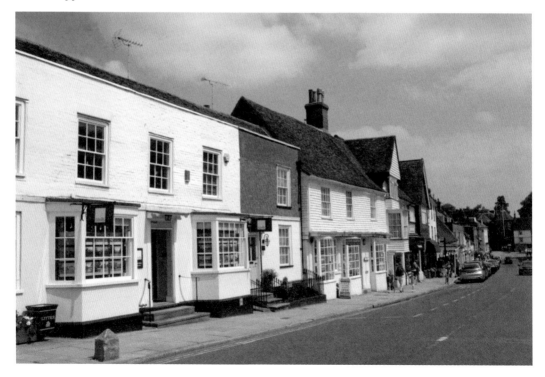

Tall House, Cranbrook
This elegant three-storey Georgian house in the Upper High Street contrasts with its more artisan neighbours. All homes here are immaculately maintained, with shiny white painted casements and lovingly tended gardens.

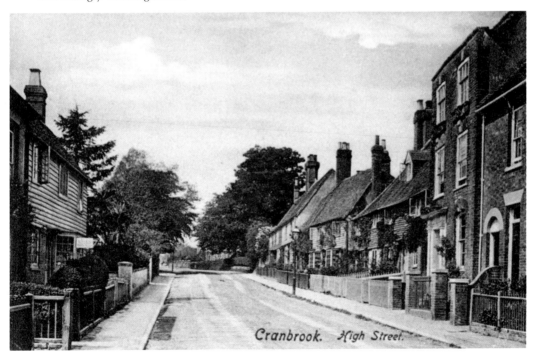

Cranbrook. High Street.

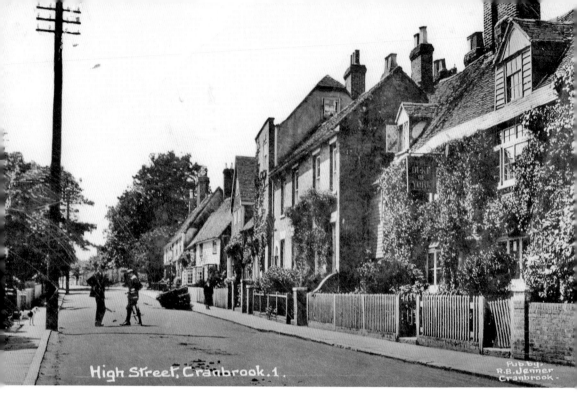

High Street, Cranbrook. 1.

Pub. by
R.B. Jenner
Cranbrook.

Upper High Street I

When the cottages in Upper High Street were built, there was no thought of accommodating the unknown motor car. The gardens, however, were as exuberant as now, and in the scene above the trend for training creepers over walls was much more popular.

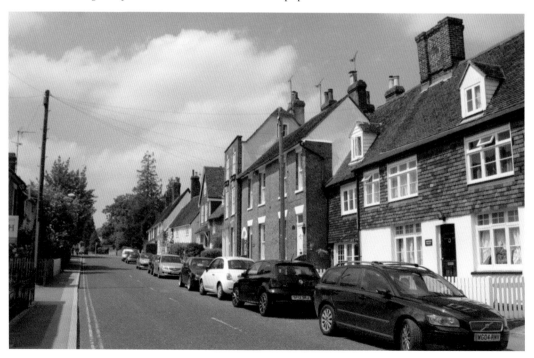

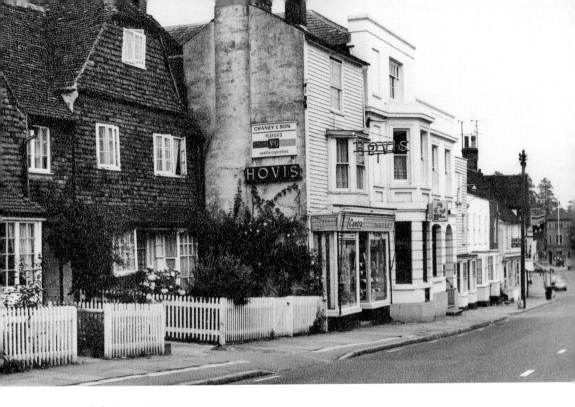

Upper High Street II

This group of Victorian buildings, which includes a branch of the National Westminster Bank, adds to the variety of architectural styles, but fits in well due to the matching uniformity of white paint.

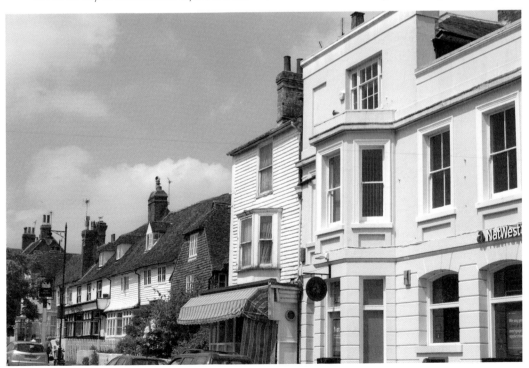

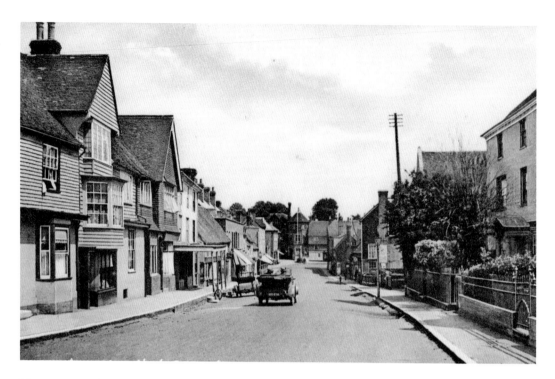

Vintage Motoring

The above scene from the 1920s postcard evokes a marvellous idea of how free and easy motoring had become when the middle classes started to buy cars. Even in towns like Cranbrook, people would take note of passing vehicles, like this open tourer. Now pedestrians go about their business oblivious to the background hum of traffic.

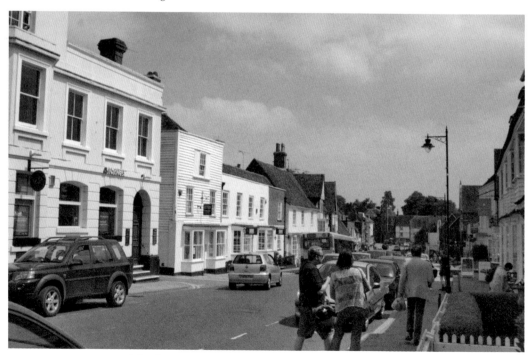

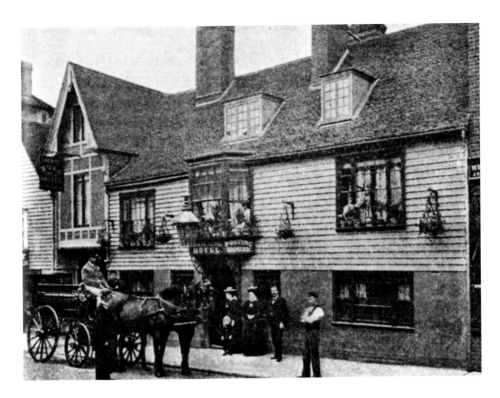

Pub Outings

The above picture of a carriage waiting for its passengers outside The Bull Hotel in Stone Street is notable for the driver's livery and the formal dresses of its potential customers. Below, a more leisurely, yet contrived, pose of a cricket team atop a covered wagon, outside the White Lion Inn, also provides a good insight into past travel methods. The Bull Hotel has long been demolished and now forms the forecourt to a shop selling second-hand furniture.

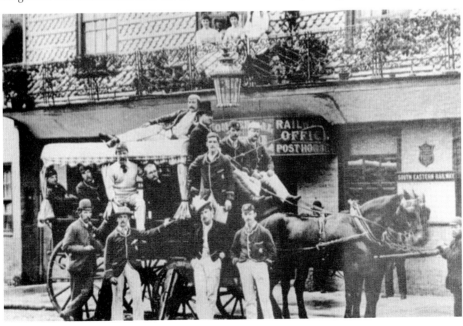

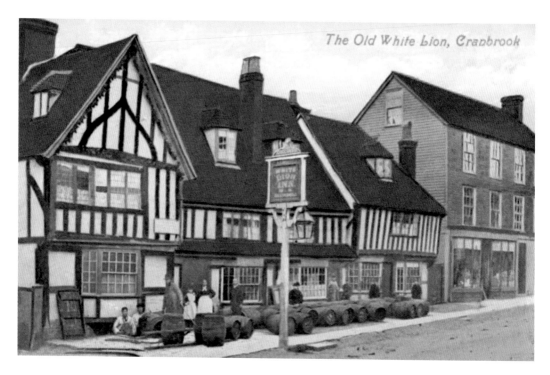

The Old White Lion, Cranbrook

White Lion Pub

The postcard image above of the White Lion pub, Cranbrook, shows wooden beer barrels awaiting storage in its cellars. On a rough calculation, these containers would have held nearly 6,000 pints of beer! With such prodigious sales, it is a wonder that it was closed and turned into a post office. Later, in 1925, the Royal Observer Corps originated in its telephone exchange. Now, considerably adapted, it has become Lloyds Pharmacy.

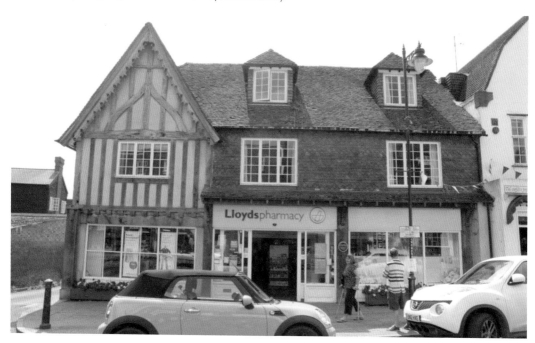

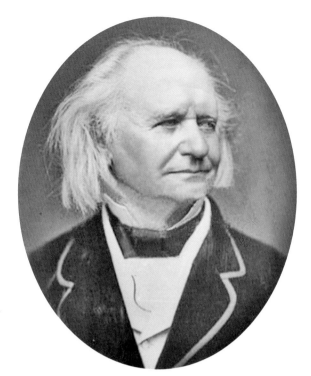

**Doyen of the Cranbrook
Colony of Artists**
Thomas Webster was the doyen
of a group of artists that moved to
Cranbrook in mid-Victorian times.
They specialised in romantic, lifelike
images of rural and domestic life and
based their style upon earlier Dutch
artists such as Vermeer. The elegant
residence of Thomas Webster, in the
High Street, is pictured below.

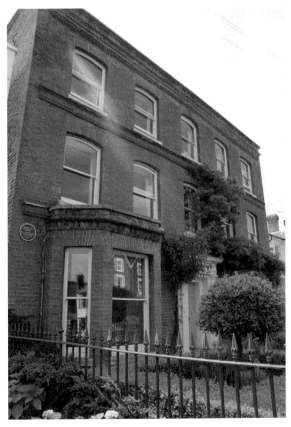

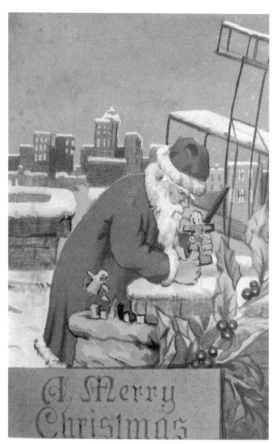

The First Christmas Card

Below is an illustration of the first Christmas card, which was designed by John Calcott Horsley, a member of the Cranbrook Colony of Artists. He began his association with this group when he met Thomas Webster at the Royal Academy of Art. Moving to Wilsley House in 1861, he is also remarkable for his sister, who was the wife of famous British engineer Isambard Kingdom Brunel. The first Christmas cards cost the princely sum of a shilling each and were slow to catch on. However, with Queen Victoria inaugurating an official one by the 1880s, cards such as these became wildly popular.

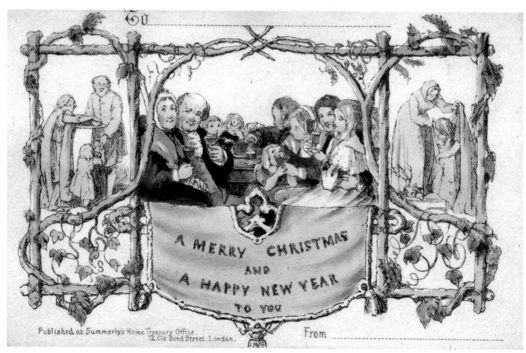

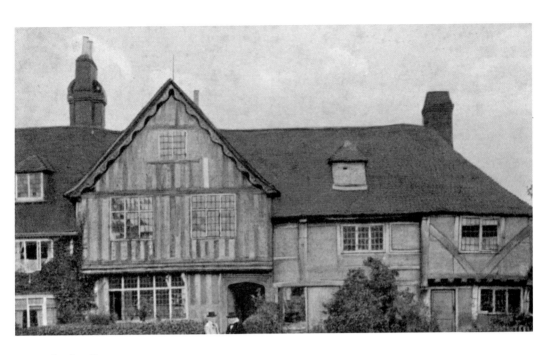

The Studios

Hardy's studio was the subject of the 1896 postcard above. The gentlemen posing by its gate certainly appear to be of an artistic, genteel disposition, although their identities are unknown. Now the quaint cottage has reverted to its former use as a dwelling.

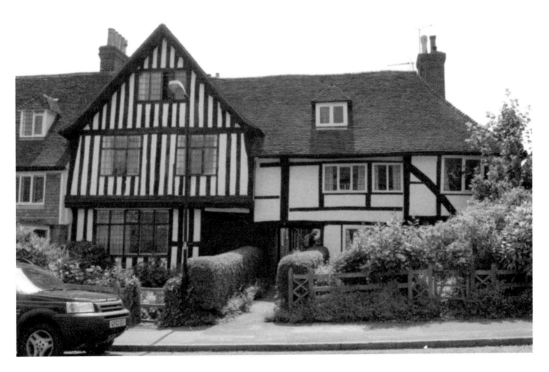

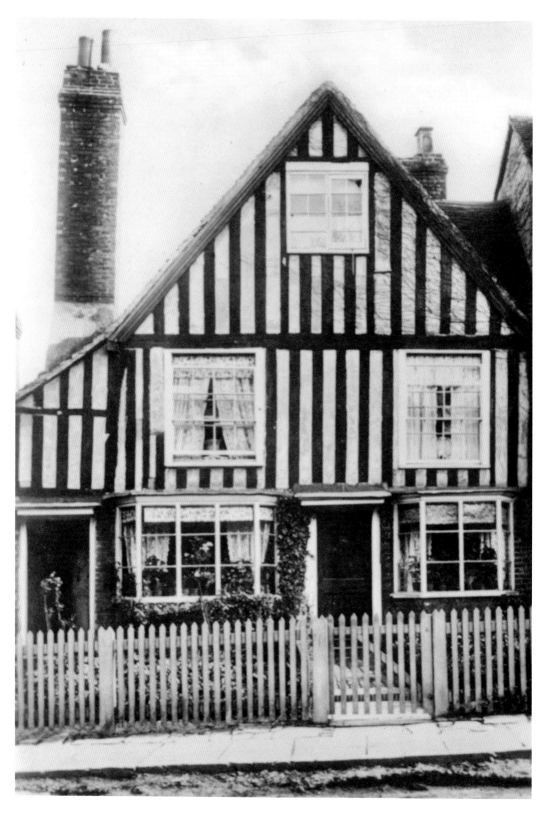

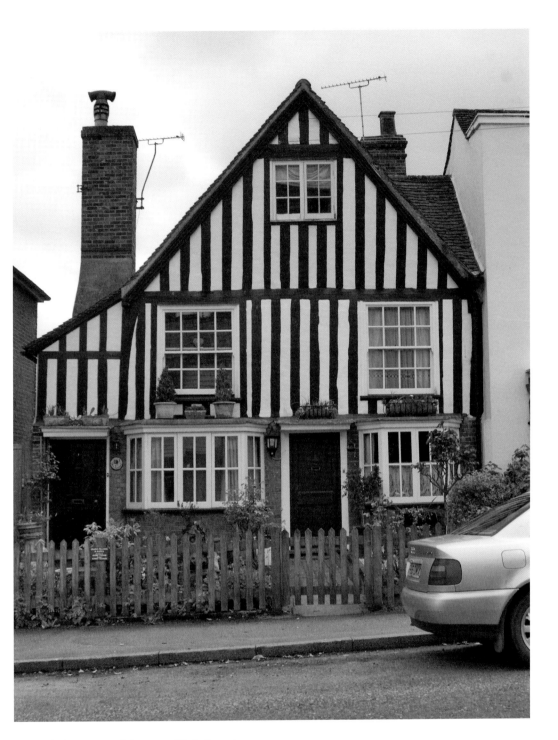

Timber-Framed Cottage, High Street

The compact, timber-framed cottage on this page shows little alteration over the past decades. Its present plant pots and attractive garden are a reminder of the general care and effort that won Cranbrook the Small Town in Bloom award in 2012. Indeed, so pleasant is Cranbrook that it was also listed in the *Times* newspaper as the third best town in Britain on 30 March 2013.

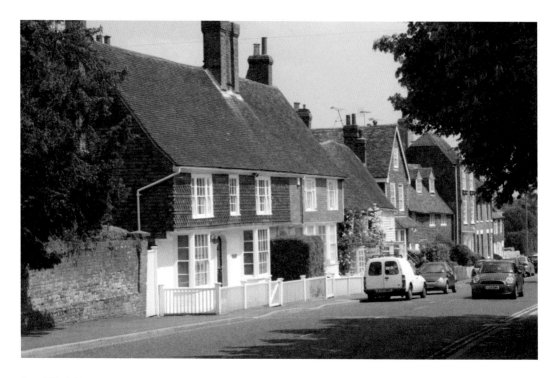

Peg Tiled Cottages

Contrasting with azure blue skies and pristine white paintwork are the red peg tiles of these cottages in Upper High Street. With imposition of brick tax, clay tiles became a cheaper, alternative, building material. However, due to their present scarcity, they are now an expensive commodity found only in specialist salvage yards.

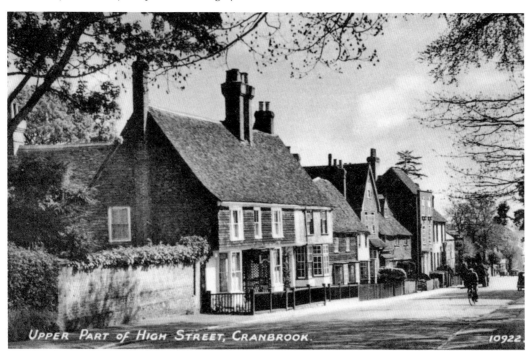

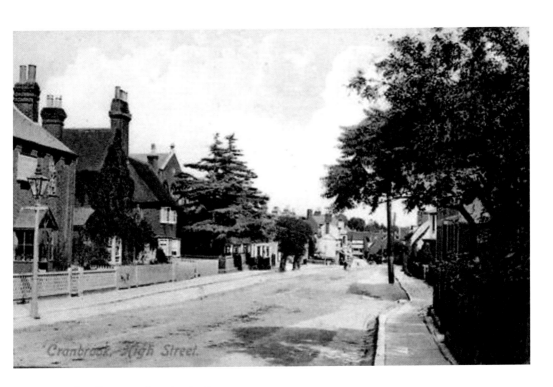

Motoring Becomes Popular in the 1930s

The postcard image below shows the first signs of motoring becoming widespread in the 1930s. The implication of this for Cranbrook was that residents' vehicles had to be left parked at the roadside. However, the scene above, dating from around 1900, shows a wide boulevard of the High Street entirely free from all traffic and indeed not designed for the dramatic changes to come.

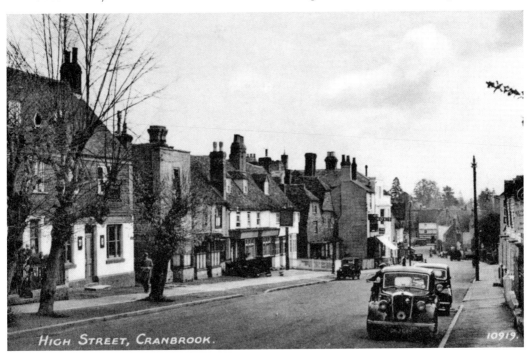

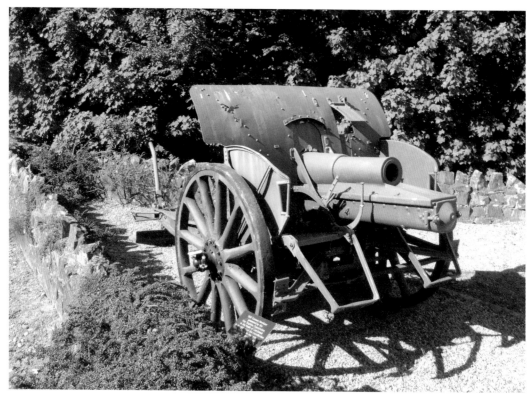

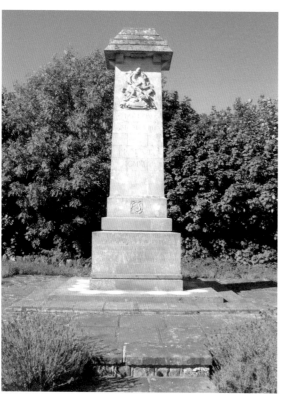

Cranbrook's War Memorials

Cranbrook was given the German field gun pictured above in 1917, by the Imperial War Commission, in recognition of its efforts and contribution to success in the First World War. The memorial, which stands nearby, commemorates the many men of the town who lost their lives principally in the two World Wars. Within St Dunstan's church, there is also a plaque to the memory of Anthony Norman, aged twenty-five, who was killed on HMS *Sheffield* during the Falklands conflict of May 1982.

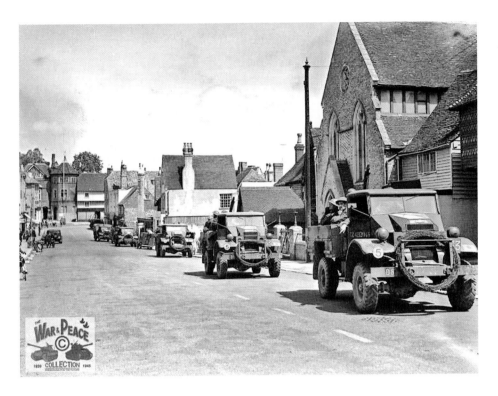

Wartime Cranbrook

The photograph above shows a Canadian troop convoy rolling through Cranbrook during the Second World War. No other traffic can be seen because petrol was rationed and many motorists had sold their vehicles or laid them up for the duration of hostilities. Cranbrook railway station was doubtless much more frequented back then than in the rather forlorn picture below of it in 1961, before closure.

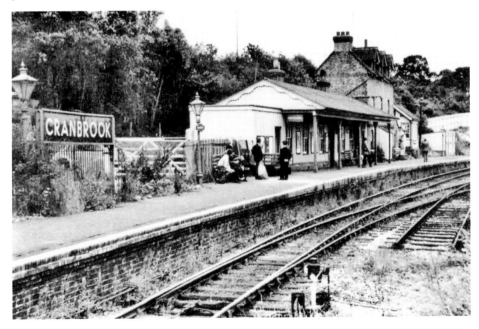

Wilsley House

Tucked away in a quiet cul-de-sac in the north-east of Cranbrook is the beautiful Wilsley House and its spectacular garden. For many years, it was owned by the Alexander family, but its most famous occupier was John Calcott Horsley who, apart from designing the first Christmas card, was also art master to Queen Victoria's children.

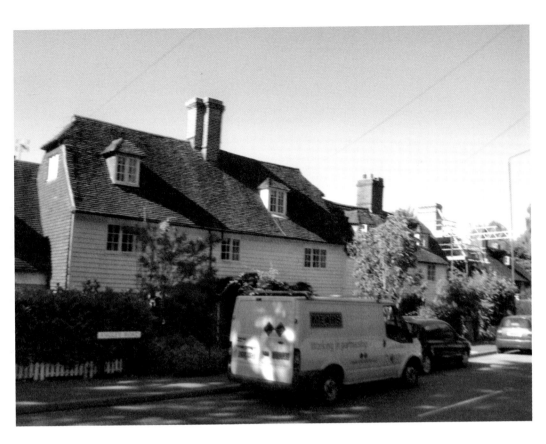

Wilsley Green

Wilsley Green is a small hamlet to the north of Cranbrook, which consists of only a few houses and smartly decorated white weatherboarded cottages. The main highway passing through has become enlarged to cope with traffic wishing to bypass the main town.

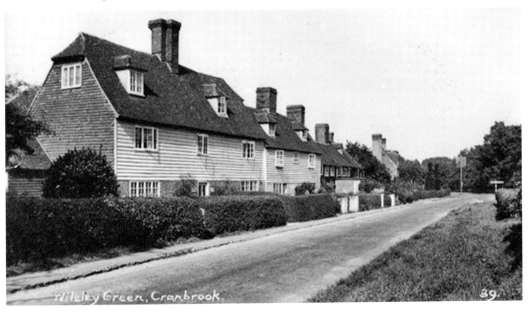

Wilsley Green, Cranbrook.

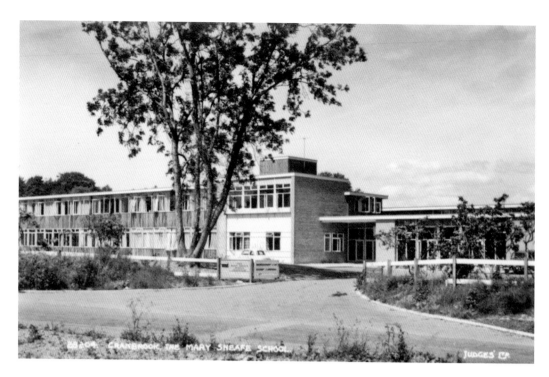

The High Weald Academy

The High Weald Academy is Cranbrook's state-run secondary school for pupils aged eleven to eighteen. It is a specialist sports college with a highly successful equestrian team and its own farm. Its modern buildings are typical of the plans for schools, developed in the post-war period when Rab Butler's 1944 Education Act was gradually implemented.

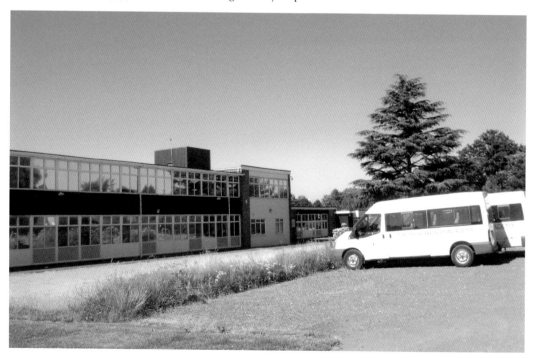

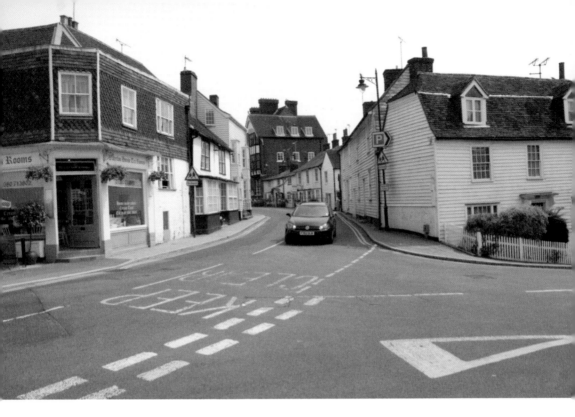

Waterloo Road

Only minor detailed changes have occurred at the junction of Waterloo Road with Stone Street. The tea room to the left of the picture above has become a popular meeting place, providing excellent beverages and tasty snacks.

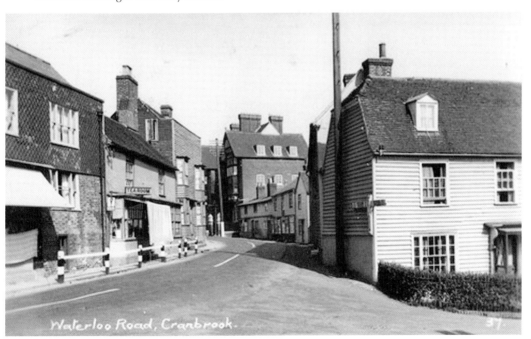

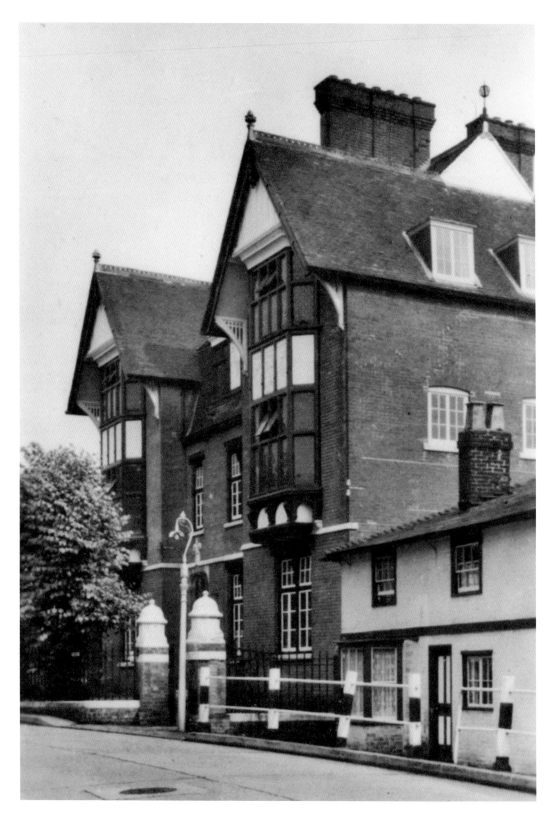

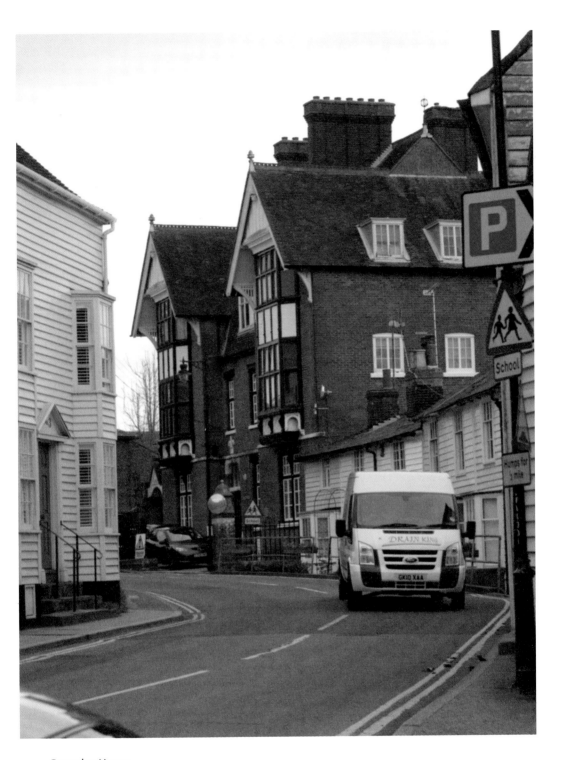

Crowder House
Crowder House in Waterloo Road is part of the Cranbrook School buildings. Apart from insignificant modifications, its substantial twin gables and robust dormer windows continue to provide solid timeless service.

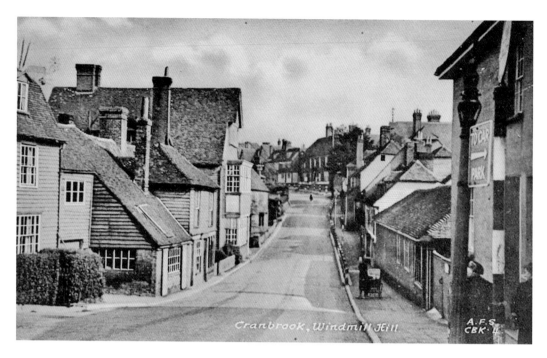

Windmill Hill

Standing proudly at the crest of Windmill Hill is a large clothier's hall. It is a medieval timber-framed building with a later Georgian façade. Most impressive is its splendid front-door portico with Corinthian columns and intricate patterns. A lock-up, a bakery and a chapel also used to operate here, but some of these have been converted into houses.

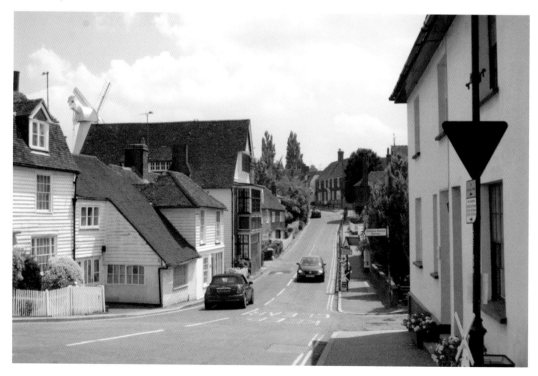

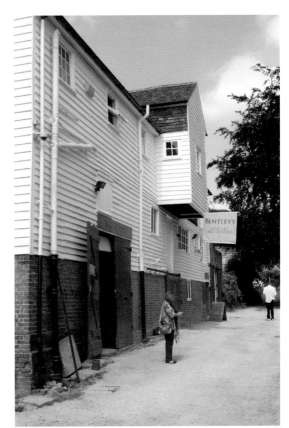

Bentley's Auctioneers, Cranbrook
Just off Waterloo Road in a converted granary, Bentley's fine art auctioneers hold monthly sales of antiques. The firm was established in 1995 and attracts collectors and dealers to its exciting sales in a venue perfect for this business.

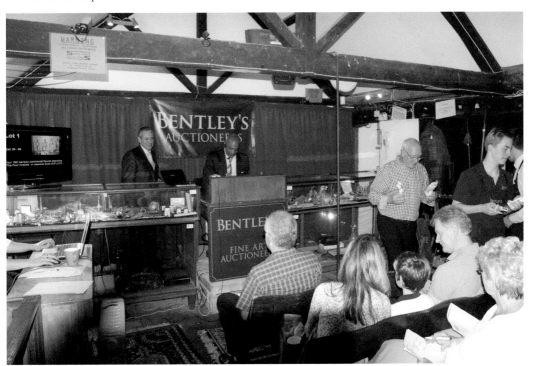

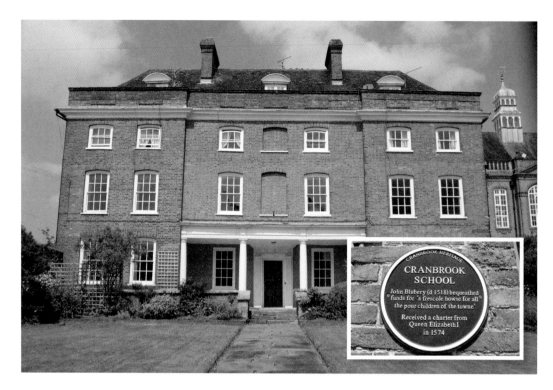

Cranbrook School I

The history of Cranbrook School began when a wealthy yeoman bequeathed his 'chief mansion' to provide a 'frescole house'. Today, the school has become a selective grammar school. Entrance is free to the brightest local boys and girls, with fee-paying boarders from further afield. This combination works well by successfully blending the traditions of both the state and independent sectors.

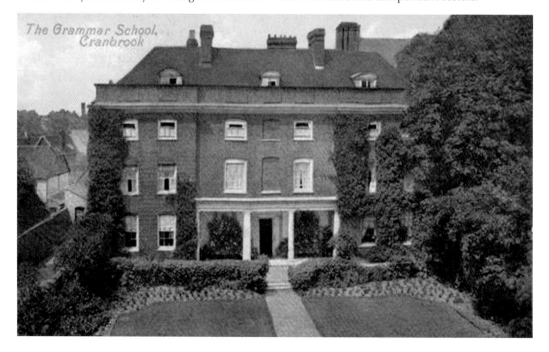

Cranbrook School II

Under the aegis of Victorian headmaster Charles Crowder, Cranbrook School grew substantially so it could also accept boarders. The building above, with its distinctive cupola, originates from the period of expansion in the nineteenth century.

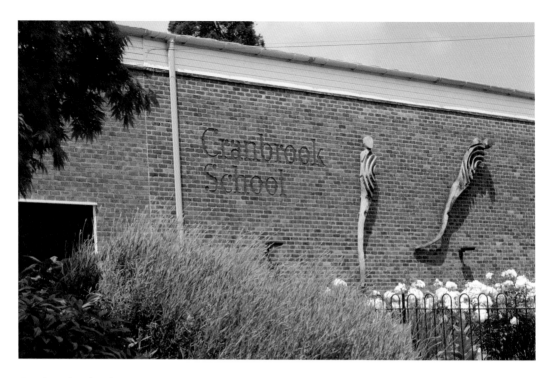

Cranbrook School III

Later phases of growth saw Cornwallis House established. However, the latest developments, seen above, do not slavishly follow a neo-Georgian pastiche yet successfully display the school's ethos of evolving with contemporary times. Academic results are exemplary, but pursuit of excellence in sport, character development and happiness are given equal importance.

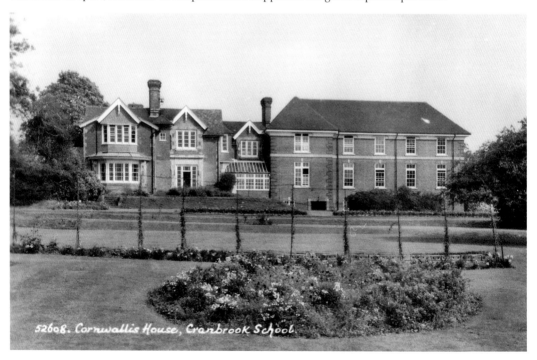

52608. Cornwallis House, Cranbrook School.

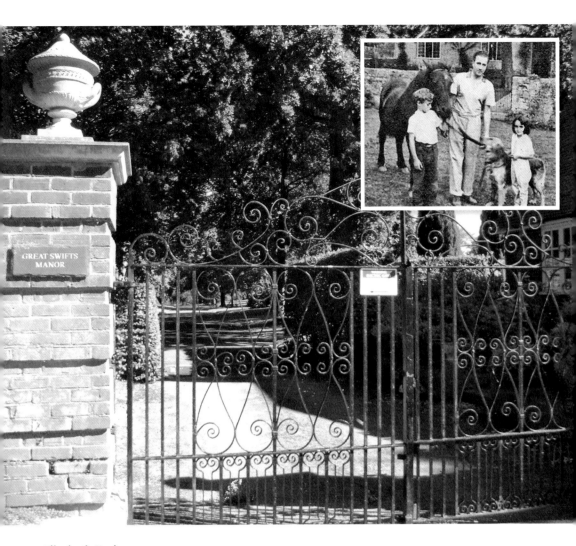

Elizabeth Taylor

In her biography, Elizabeth Taylor described her childhood days in Cranbrook as some of the happiest of her life. Her parents had a weekend retreat called Little Swallows on the Great Swifts estate belonging to her friend Victor Cazelet. During summer months, Elizabeth would wander the countryside on her beloved pony Betty – a present she received from her bachelor godfather Colonel Cazelet when she was three years old.

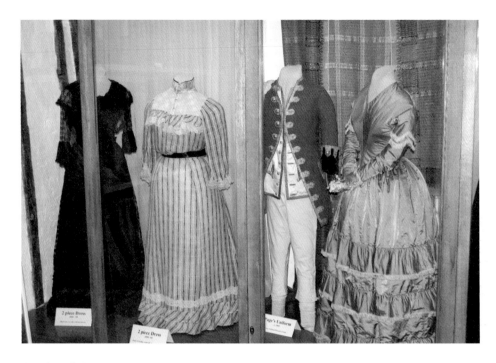

Cranbrook Museum I

Tucked away off Carriers Road is Cranbrook Museum, run by a group of volunteers from Cranbrook History Society. The fifteenth-century farmhouse, which houses over 6,000 exhibits within 11 major collections, was a manor attached to the rectory. The historic costumes above are some of its many fascinating, well-presented attractions. Also notable is a collection of stuffed birds and eggs, amassed by Cranbrook naturalist and African explorer Boyd Alexander in the nineteenth century.

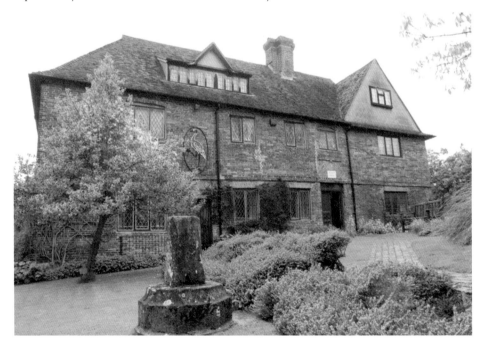

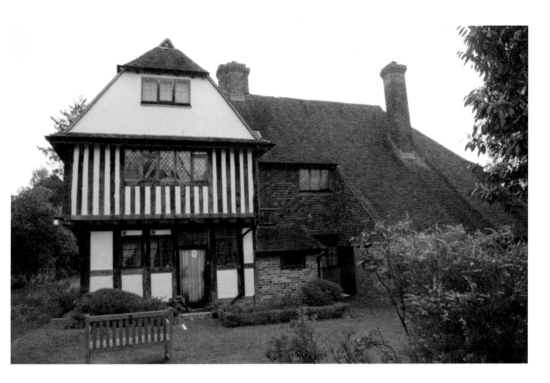

Cranbrook Museum II

Pictures produced by the Cranbrook Colony of Artists can be viewed at the museum, along with a range of more humble domestic artefacts, which have fallen into disuse due to the march of science and technology. While the immaculate building dating from 1480 alone is worth a visit, no mention of this tourist attraction should fail to praise its beautifully kept gardens.

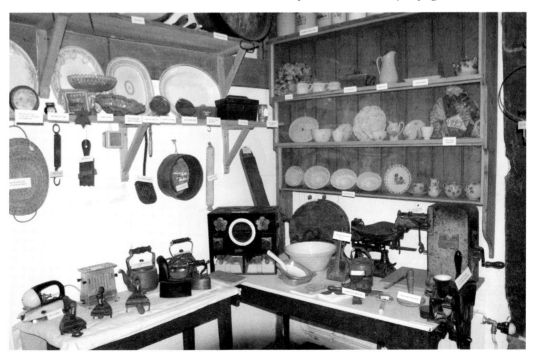

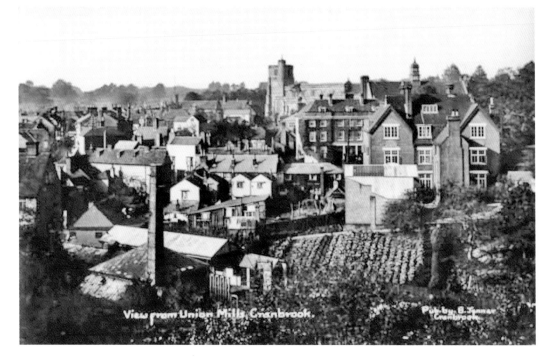

The View from the Windmill

Frequently open to visitors, the view from the top of Union Mill has instant appeal for photographers. The before and after shots here are of vistas to the north, which encompass the extensive grounds of Cranbrook School and St Dunstan's church.

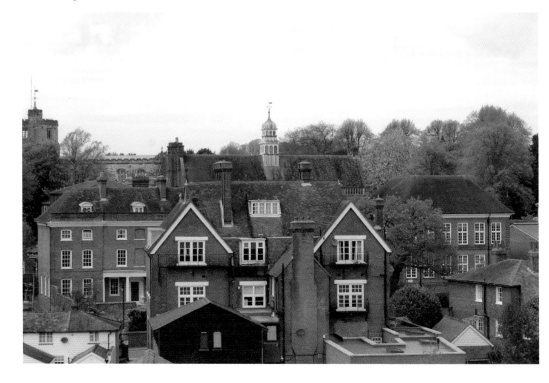

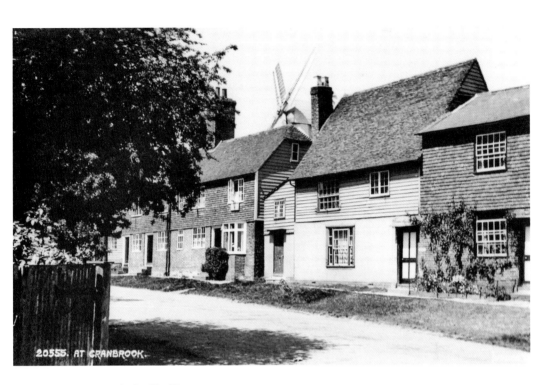

20555. AT CRANBROOK.

Cottages on Windmill Hill
The pretty period cottages in these pictures exemplify Cranbrook's much-loved architectural DNA. Humble and unobtrusive, their honest durability and unadorned simplicity evoke nostalgia for a simple, contented lifestyle within a harmonious community.

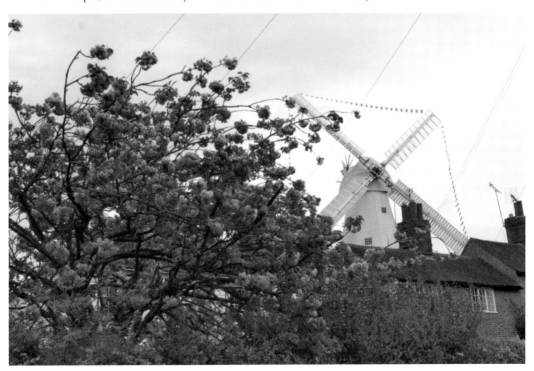

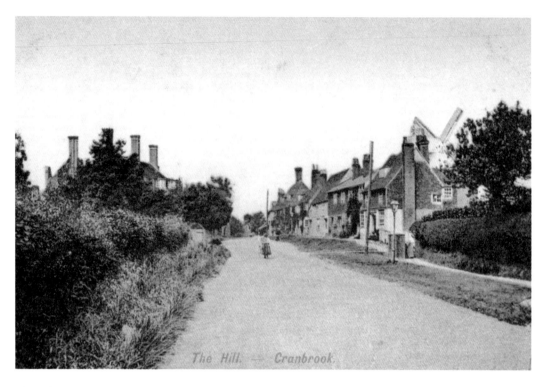

The Hill, Cranbrook

The old image above shows that the approach to Cranbrook from the east was much more rustic in Edwardian times than today. However, despite present road markings, pavements and bollards to prevent parking, the countryside to the east remains lush and unspoilt.

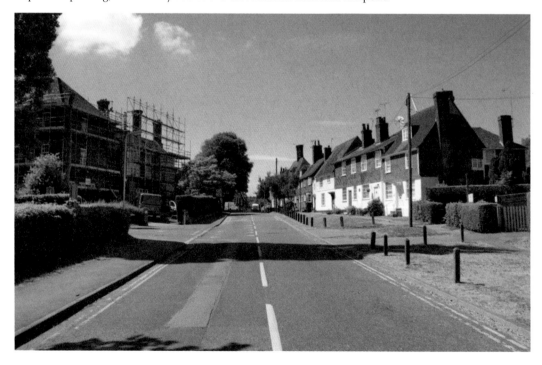

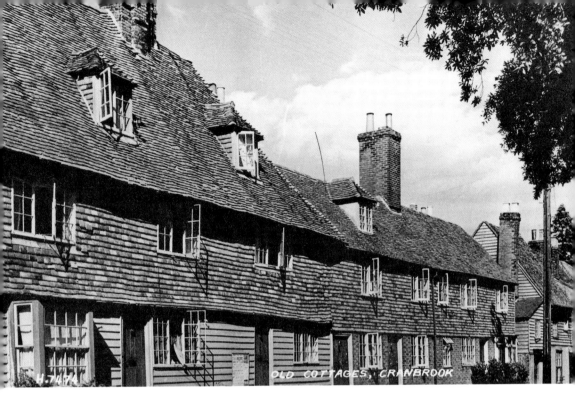

July Heatwave

The photograph below was taken at the height of a wonderful bout of hot weather in July 2013. Coincidentally, the old sepia shot above must have been taken on a similar sort of day, as almost all windows are opened for air ventilation without a concern for potential burglary.

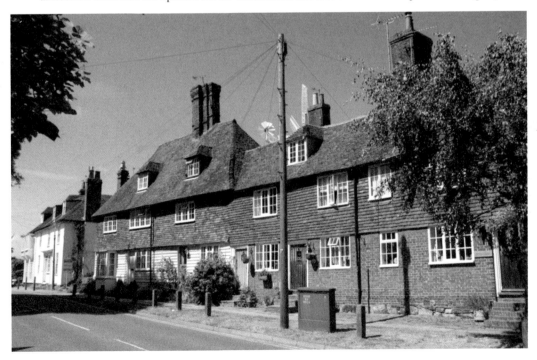

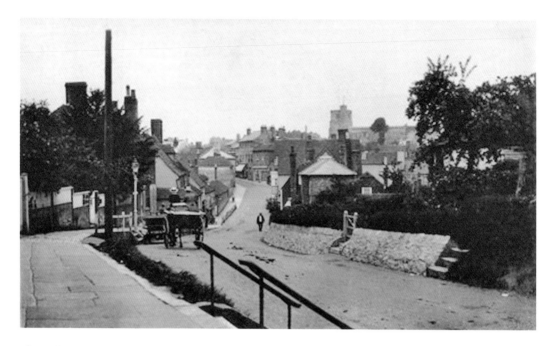

The Hill, Cranbrook

Facing westwards from the Hill, the road passes St David's Bridge and moves into the heart of Cranbrook via Stone Street. The silhouette of St Dunstan's, known as the Cathedral of the Weald, rises above the chimney pots beyond. In the contemporary photograph below, its steeple is encased in scaffolding to facilitate renovation.

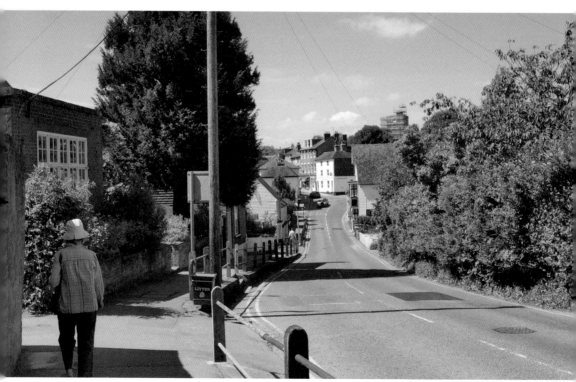

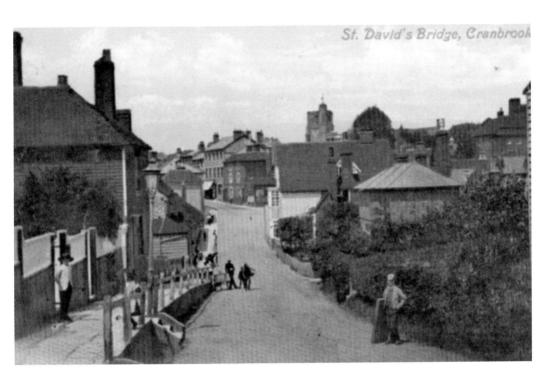

St David's Bridge I

A baker's handcart and delivery boys wait outside the bakery in the old image above. Now this premises has become a house, but its original hanging shop sign of golden pretzels remains as a reminder of its former use.

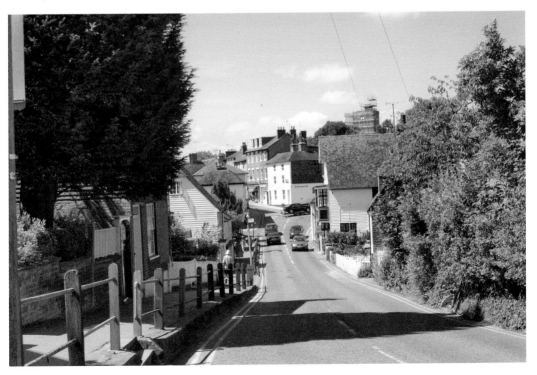

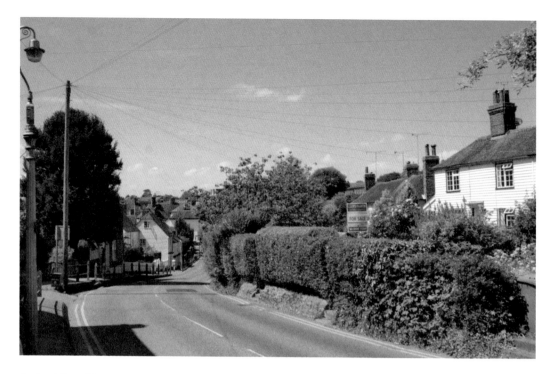

St David's Bridge II

With the advent of garden centres and supermarkets selling pre-prepared vegetables, garden design has changed dramatically over the past hundred years. Nonetheless, this corner of Cranbrook appears timeless with identical clipped hedges and the same abundant growth of trees and shrubs.

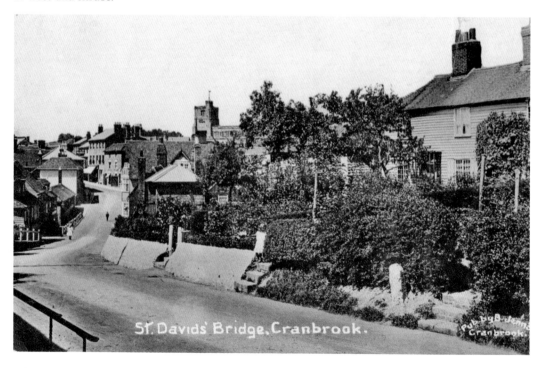

St. Davids' Bridge, Cranbrook.

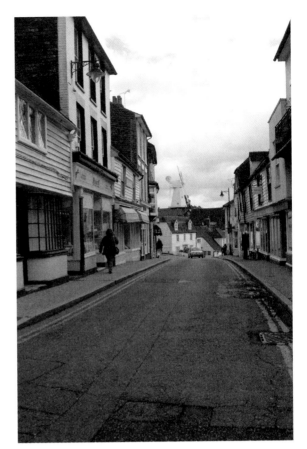

Libraries

In the old image of Stone Street below, a sign advertising a lending library can be seen on the right. Charges were 2*d* per volume per week. An older library on the left-hand corner of Market Cross existed in Regency times (*see page 16*). One wonders what its scale of fees might have been, considering the greater purchasing power of money then. Today, Cranbrook has a modern public library run by Kent County Council in Carriers Road.

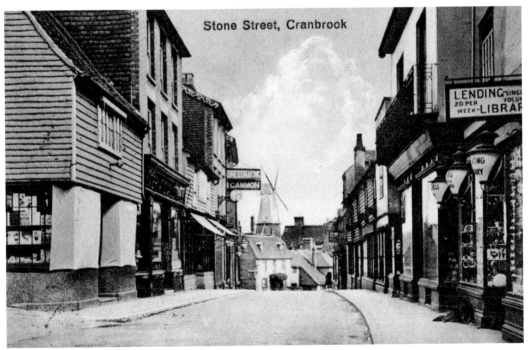

Stone Street, Cranbrook

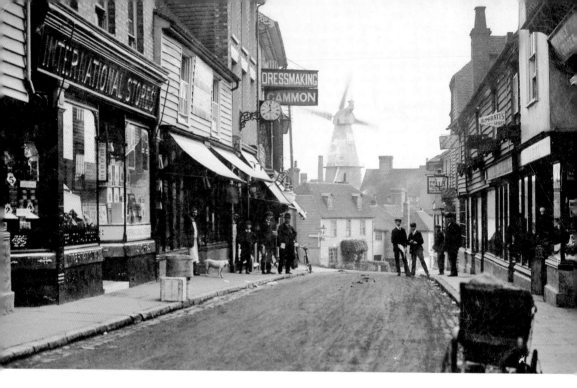

Stone Street I

These old images of Stone Street accurately portray the mood and atmosphere of a sleepy Kentish town just after the First World War. In the picture below, a charming pony and trap waits in the foreground. Beyond is a vintage Edwardian car, while, in the middle distance, all forms of transport are finally represented by a steam tractor.

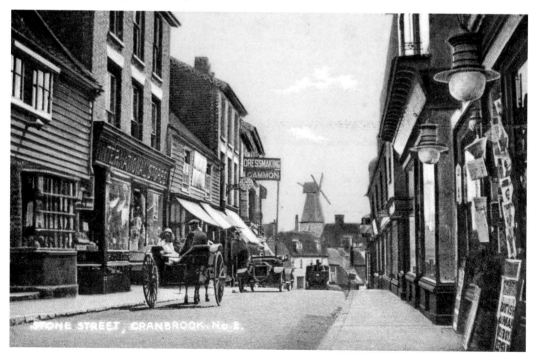

STONE STREET, CRANBROOK. No. 2.

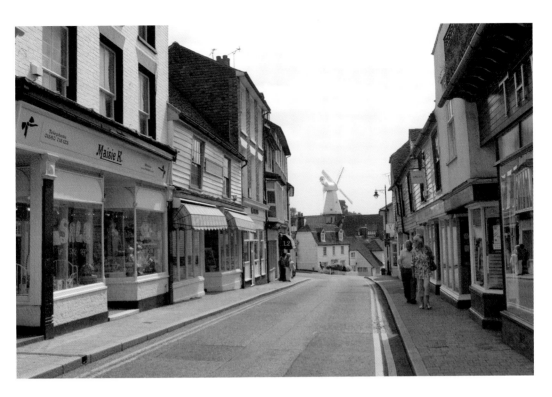

Stone Street II

These recent photographs of Stone Street show how the type of retailer has changed without any structural alteration to the shops themselves. For example, the International Stores (a grocer's) is now a gift shop called Maissie K, and Gammon the dressmaker's has disappeared altogether.

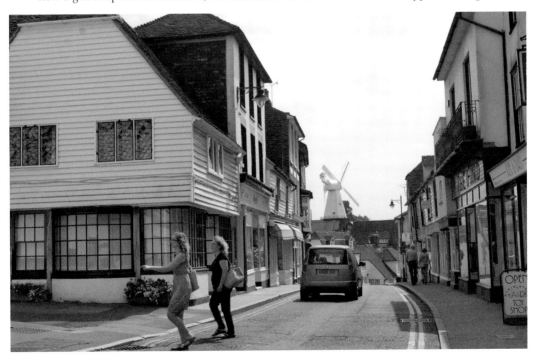

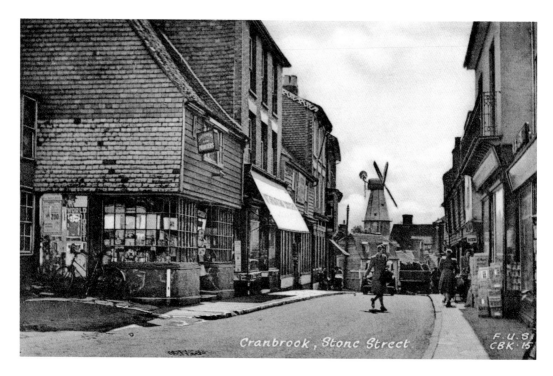

Stone Street III

So minor are the detailed variations between these two pictures from the 1930s (*above*) and around 1900 (*below*) they could be used in a 'spot the difference' competition. Sadly, the protruding street clock was removed and, of course, horse droppings in the street became increasingly less prevalent.

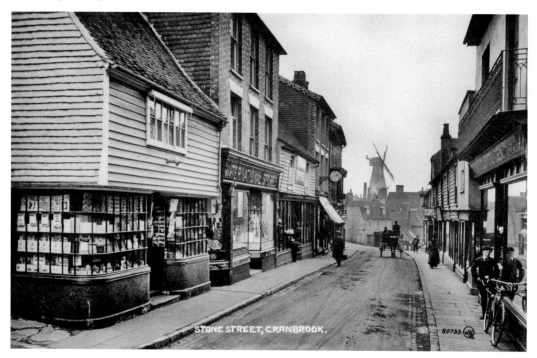

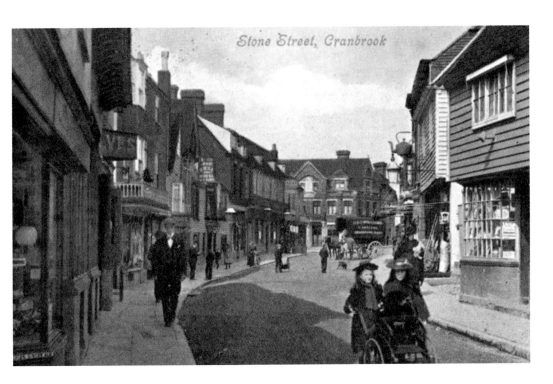

The Bull Hotel

In the postcard above, the Bull Hotel still existed. The gable holding its sign and the adjacent roof span left a mark on the wall of the next building, which is still discernible in the photograph below. Carriers became an important replacement business after the weaving industry declined, and it is interesting to note a horse van of a local firm coming from the direction of Carriers Road.

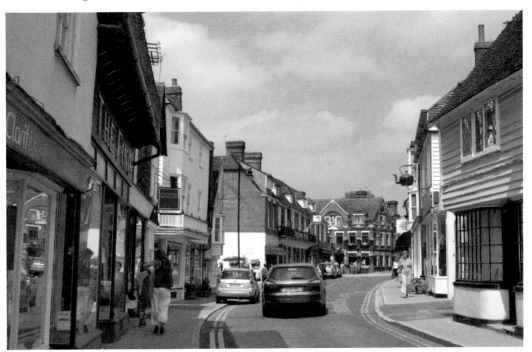

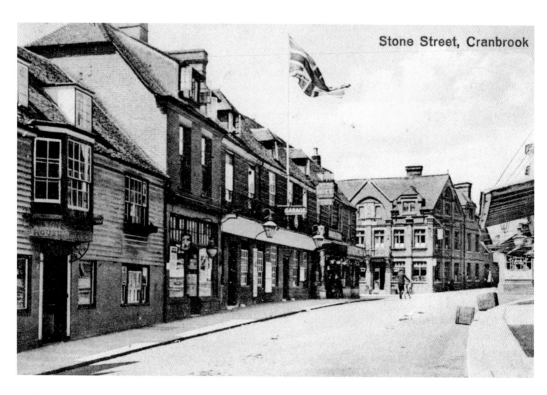

Bull Hotel II

The before and after pictures here further illustrate the Bull Hotel and the gap left by its removal. It is believed a motor garage operated here during the 1930s, while today there is a charity shop.

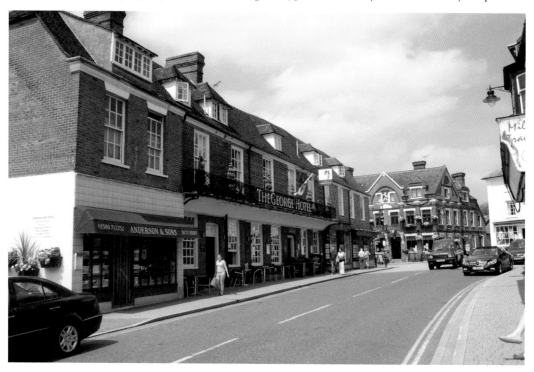

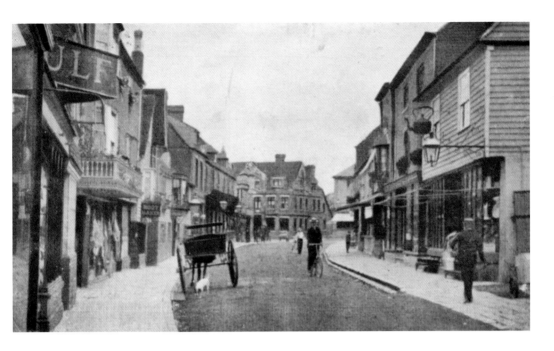

Summer in Stone Street

These two images of Stone Street, during a quiet summertime, reveal subtle differences over the past hundred years. Headgear in the shape of straw boaters was *de rigueur* in 1900, and 'sit up and beg' bicycles were extremely popular. Double yellow lines do not deter some expedient motorists from parking today, but leaving a dog cart parked in the street would now cause considerable commotion.

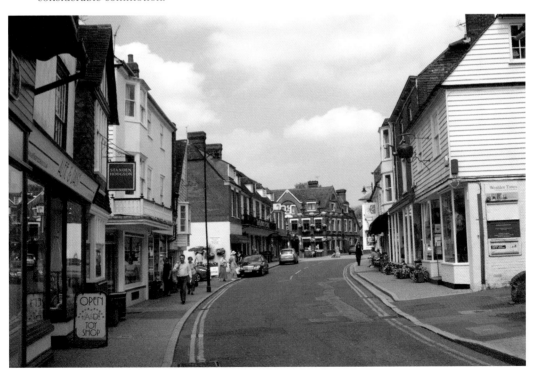

Hat Factory

Off a narrow alley from Stone Street, the converted hat factory of William Tooth can be found. This water-powered works was built in 1817 and produced the locally renowned beaver hats. The Tooth family became well-respected local businessmen, with William's two sons, John and Robert, branching out into the brewery business at Bakers Cross. John eventually left for Australia to help establish the Kent Brewery in Sydney, while Robert's good fortune lead to him purchase Swifts.

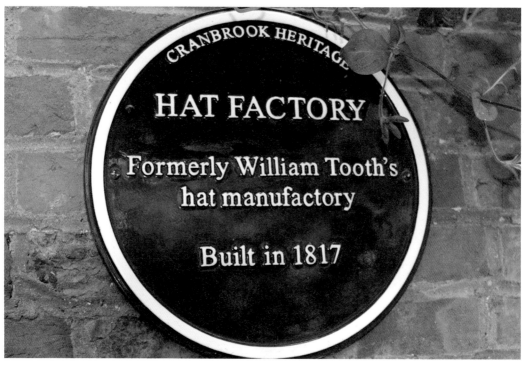

CRANBROOK HERITAGE

HAT FACTORY

Formerly William Tooth's hat manufactory

Built in 1817

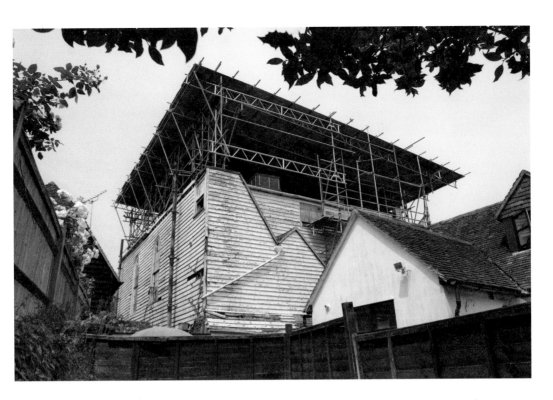

Providence Chapel II

Empty for eighteen years, Providence Chapel was encased in protective scaffolding in September 2012. Built in 1795, and Grade II* listed, future adaption could create a marvellous opportunity for live performance groups to stage their productions here.

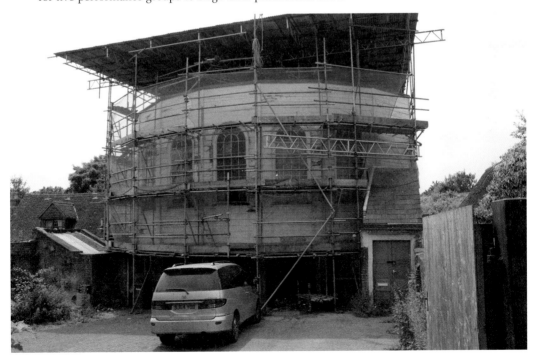

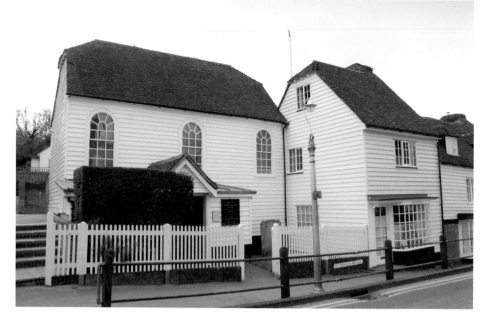

Strict and Particular Baptist Chapel

A chapel has existed on the Hill near St David's Bridge since at least 1710. It was for Strict and Particular Baptists who arose in seventeenth-century England. They believed in a Calvinistic form of particular redemption. Its minister from 1785 to 1827, James Skinner, was one of the Dobell family creditors when their nearby windmill went bankrupt in 1819. Converted from two weatherboarded cottages, the rounded window frames and the tombstone in the front are clues to its use. This simple but graceful form of fenestration was also used in the construction of the General Baptist chapel in the High Street in 1807.

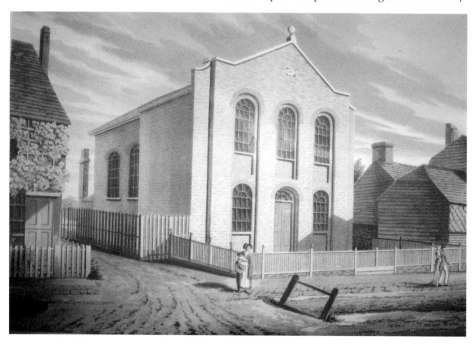

High Street Chapels

Cranbrook's first Congregational
chapel, dating from 1831, was
replaced by the yellow-brick Gothic
Revival version opposite in 1857. It
cost £1,400 to erect and is typical of
this period of church architecture,
with its rose window and tracery. It
stayed outside the United Reformed
church when the Congregational
church merged with the Presbyterians
in 1972. Further up the High Street
on the opposite side, the General
Baptist chapel was built in 1807. It
has now become the Cramp Institute,
a sports and social club. Clement
Cramp was a local philanthropist,
who established a coffee house and
reading house in St David's Bridge for
the use of working men.

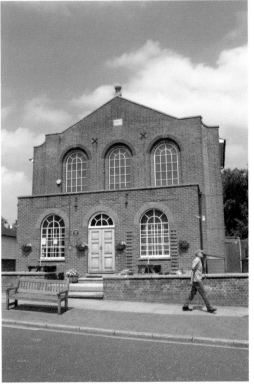

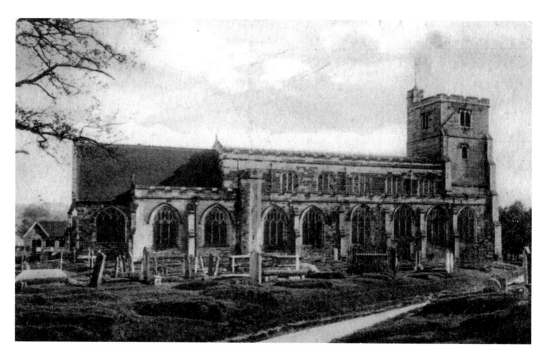

St Dunstan's

St Dunstan's, dedicated to a Saxon prelate in 1290, was built in the fourteenth and fifteenth centuries, when the woollen cloth trade was at its peak. Earlier churches are thought to have existed on this site, owned by Christ Church, Canterbury.

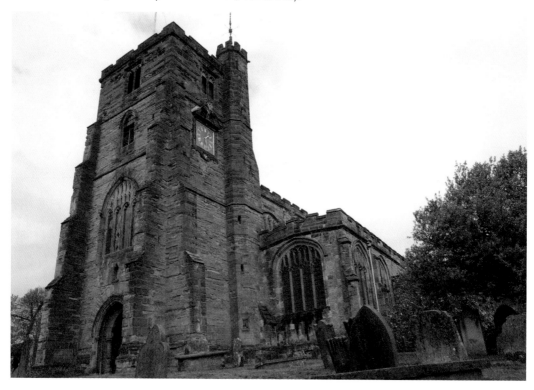

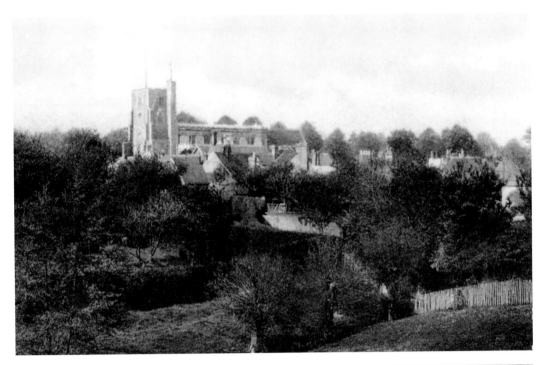

St Dunstan's Church II

The spacious and lofty interior of St Dunstan's is sometimes used for concerts. Friends of St Dunstan's organised a flower festival in 2013, with contributions from twenty-eight organisations – appropiately themed 'Community' – raising some £3,000 towards its tower project. An extremely rare feature of its interior is a full immersion font built under a stone staircase leading to the room over the south porch. This room was used to imprison Protestant martyrs during the reign of Queen Mary.

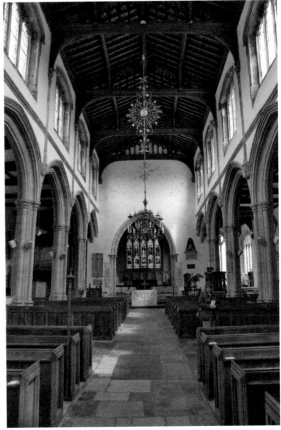

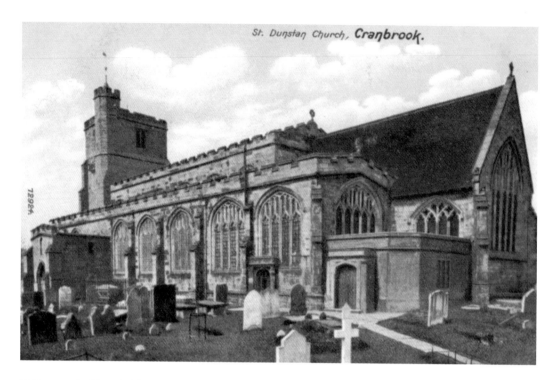

St. Dunstan Church, **Cranbrook.**

St Dunstan's Church III

St Dunstan's contains many treasures, including a well carved coat of arms of George II given in 1756, a fine set of eight bells cast at Whitechapel Foundry, and an organ that was part of the display at the Great Exhibition of 1851. Most interesting, however, is its clock mechanism, which was the model for Frederick Dent's Big Ben.

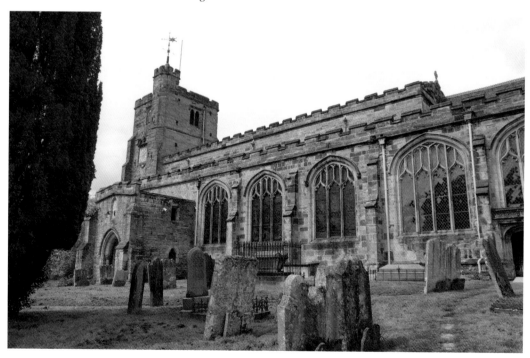

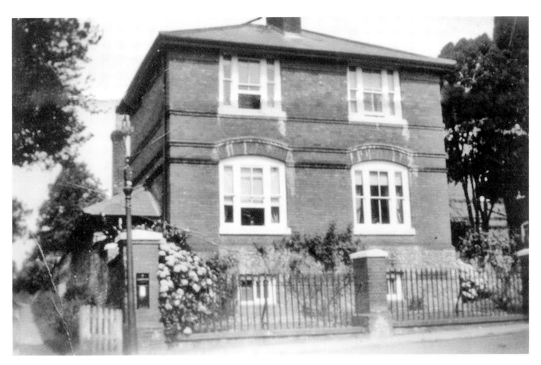

Cranbrook Police I

Cranbrook's police force started around 1850, when the Kent justices appointed a Superintending Constable for each of the twelve rural petty sessional divisions. These supervisory roles were in such demand by experienced policemen that the vacancy at Cranbrook attracted sixty applicants. Above is an old photograph of the police station in Waterloo Road and below its illuminated sign now preserved in the local museum.

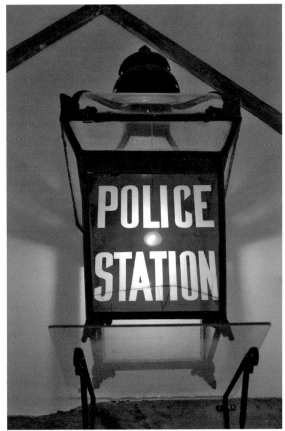

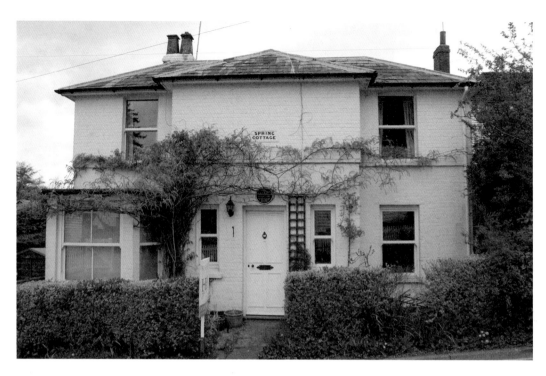

Cranbrook Police II

The old lock-up on the Hill (which was used between 1850 and 1864, predating the move to Waterloo Road) has been converted into a pretty cottage, pictured above. It contained two cells for prisoners with a room between them for the warder. Below is a faded group shot of Cranbrook District's police force, taken sometime between the two World Wars.

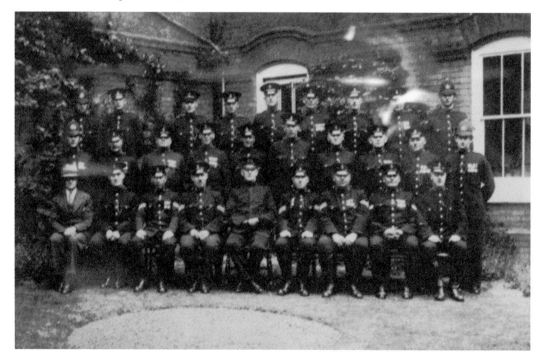

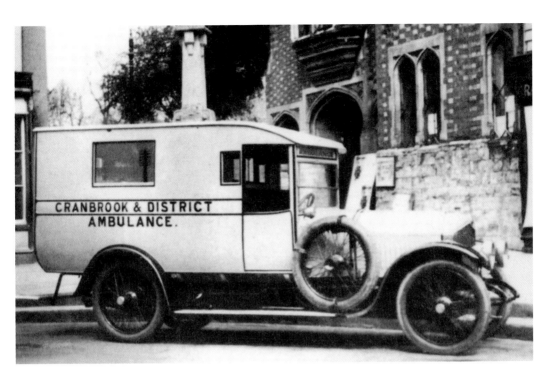

Emergency Services 1

Pictured above is Cranbrook's ambulance from the 1920s. Recent plans have been announced for a new ambulance station at Tomin Ground, Angley Road. The currently derelict premises in Dr Hopes Road are the subject of a scheme for conversion into housing. The old print below shows a major fire, which struck a terrace of timber-framed houses near Market Cross in 1840. The horse-drawn pumps failed to extinguish the blaze. After this disaster, replacement buildings were made from bricks.

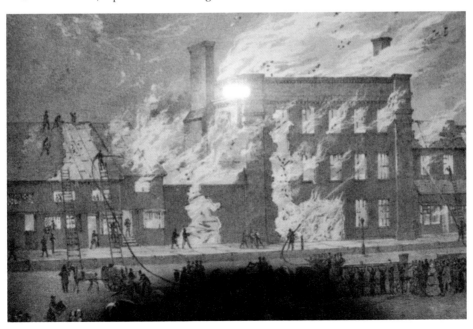

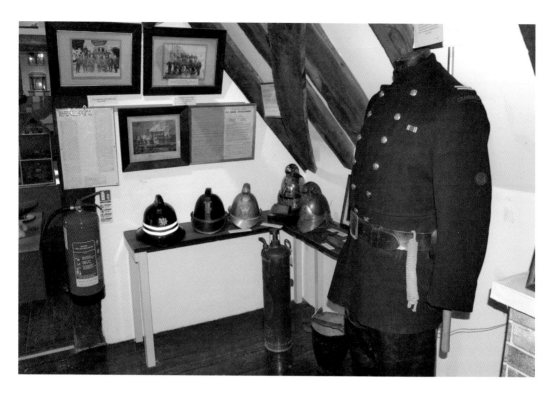

Emergency Services II

The present fire station at Cranbrook, pictured below, is conveniently placed in the High Street for strategic reasons. It was previously underneath the vestry offices at Market Cross, where no doubt the helmets and uniform from this era originated before becoming exhibits in the local museum.

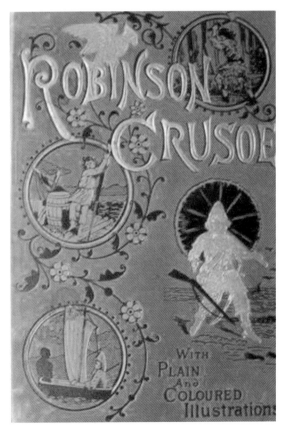

Daniel Defoe

Daniel Defoe was first linked to
Cranbrook while hiding from the
King (who he had offended with his
outspoken pamphlets). It was at this
time that he secretly wrote *Robinson
Crusoe* in a nearby cottage. This
larger than life character, who had
multifarious talents as a trader, prolific
writer and spy, is credited with starting
the literary form known as the novel.

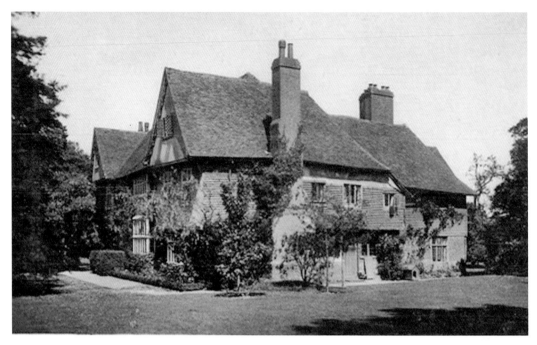

Cranbrook in Bloom

No small part of Cranbrook's considerable visual charm is attributed to its gardens. Recognition of this was gained in 2012 when it became the winner of best small town in bloom in the South and South East. Of the many properties that have long been considerably enhanced by exceptional grounds, Wilsley House continues to excel.

Impressive Doorways

The early Georgian entrance to Hill House, the former home of a clothier, does not fail to impress with its flourishing scrolls. On a smaller scale, the matching tones of clematis and front-door paint of a cottage in the High Street are equally admirable for such careful attention to detail.

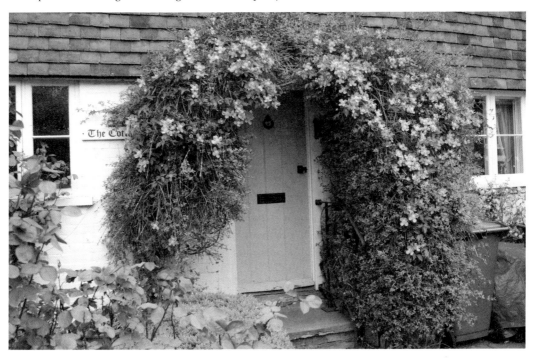

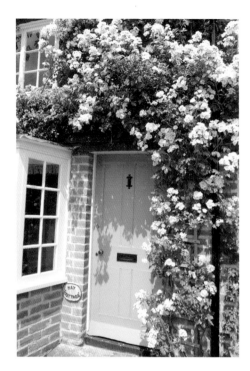
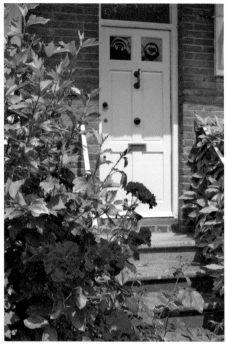

Roses Around the Doors I

These snapshots of front doors on this page and the following two pages, adorned by burgeoning flowers, most eloquently reinforce the opening remarks of Cranbrook's official website: 'The sky is grey and gloomy elsewhere, but in Cranbrook bright sunshine lights up the rows of white houses and polishes every brightly painted front door'.

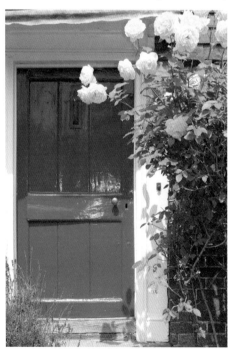
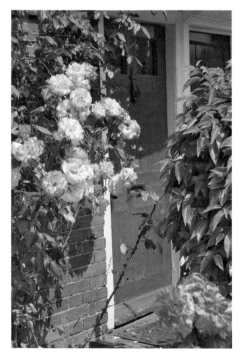

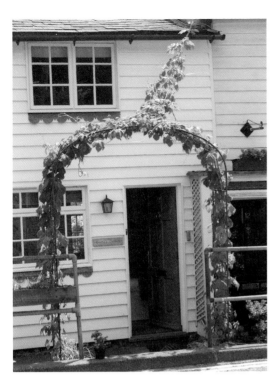

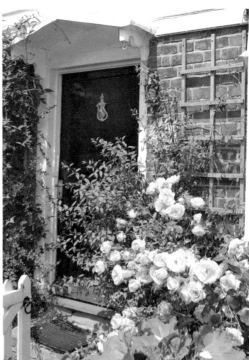

Roses Around the Doors II

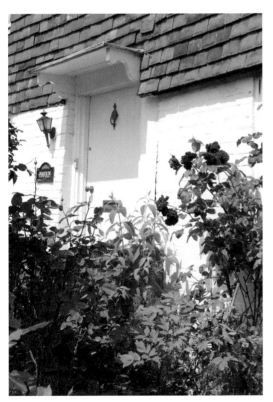

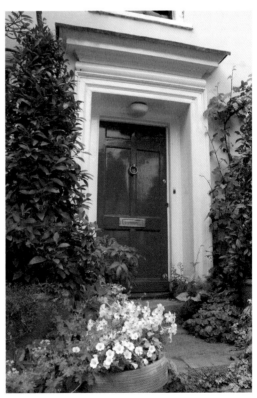

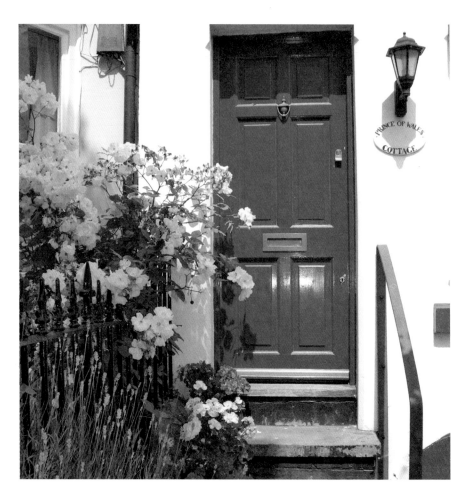

Roses Around the Doors III

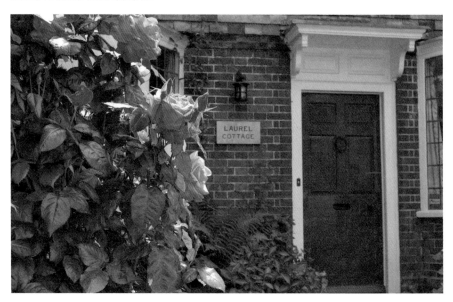

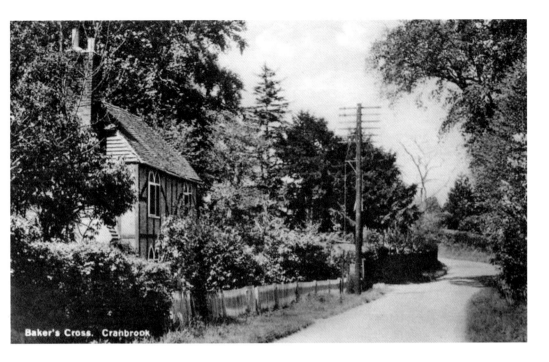

Baker's Cross. Cranbrook

Baker's Cross and Goddards Green

The old sepia pictures on this page are of two small settlements east of Cranbrook. The former is named after John Baker, who was Chancellor of the Exchequer in the reign of Queen Mary. It is said that while on a journey to Cranbrook to have two Protestants executed, he learned of his monarch's death and turned back at the point where three roads meet. Goddards Green is where a chest hospital for the treatment of tuberculosis was established in 1907. It has now become a hospital treating a range of illnesses for both private and NHS patients.

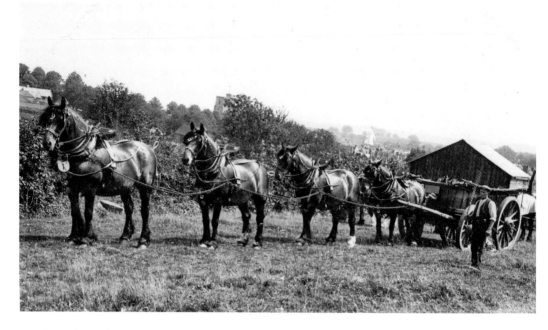

Rural Cranbroook I

The scenes here depict a bygone age of farming in the countryside around Cranbrook. The picture above is of a prize team of four draught horses from Iden Green exhibiting at Cranbrook horse show sometime before 1933. Below is a glimpse of the many hop pickers who invaded the area in September for harvesting. Hoards of these, many of which came from London, travelled here by train and stayed in temporary accommodation near the hop fields.

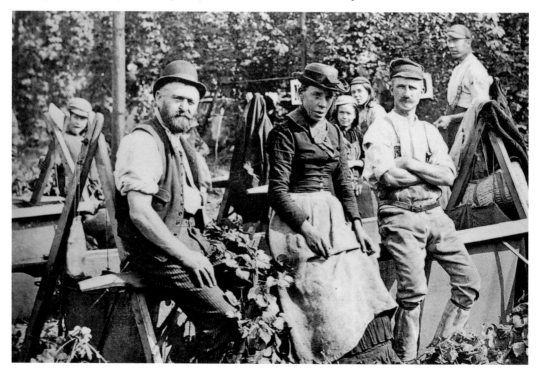

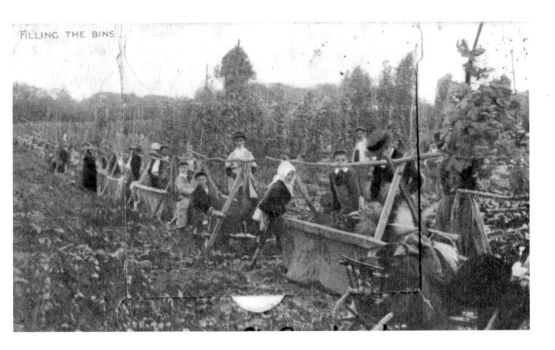

FILLING THE BINS

Rural Cranbrook II

Above, Edwardian women and children are engaged in filling bins with hand-picked hops. They were paid piecework for this tedious task, so often all family members contributed. Today, the laden bines are cut down and taken to a farm building where the pungent hop flowers are mechanically removed.

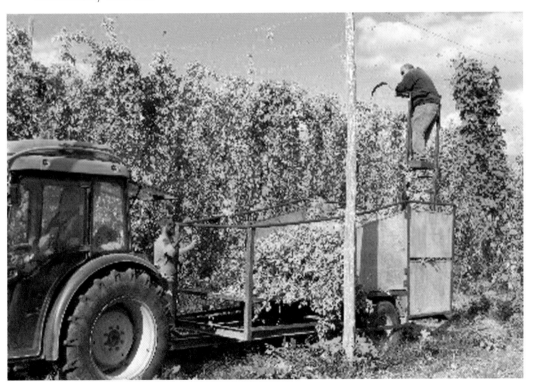

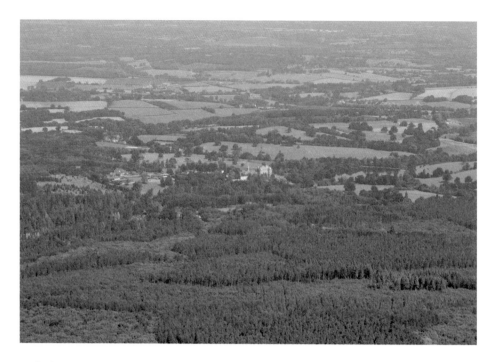

Bedgebury

The aerial photograph above shows the vastness of Bedgebury forest, which covers some 10.5 square kilometres south-west of Cranbrook towards Flimwell. This ancient woodland of poor sandy acidic soils encompasses the 320 acres of Bedgebury Pinetum. Viscount William Beresford (a general who fought with Wellington in the Peninsular Wars) established this collection of conifers in the 1850s, but it fell under national direction in 1925. Below is a closer-up view of stately Bedgebury Park, which became a school in 1919 and has only recently closed.

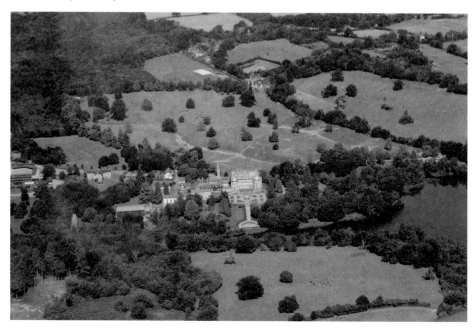

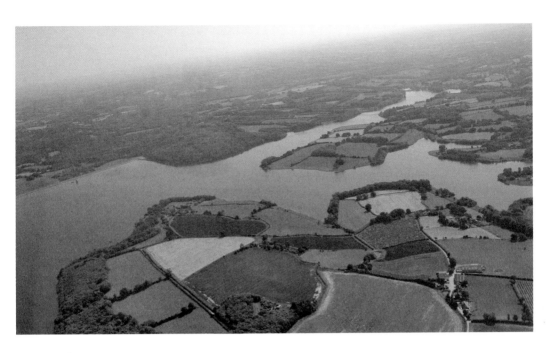

Bewl Water

Midway between Cranbrook and Tunbridge Wells, south of Lamberhurst, lies Bewl Water. This huge water reservoir was created between 1973 and '75 by damming and then flooding a valley. Filled with 31,300 million litres of water, it is now the largest body of water in south-east England. During winter months, it is replenished by water from the River Medway when its flow exceeds 275 million gallons per day.

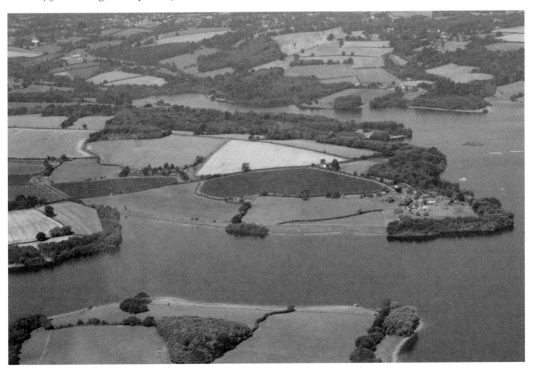

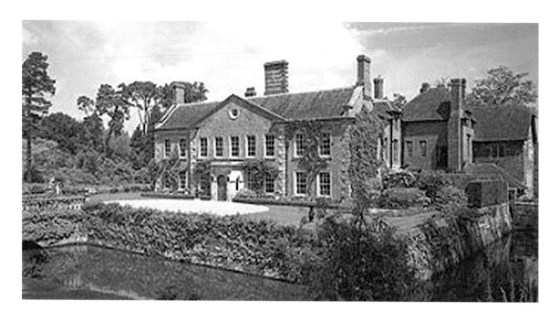

Glassenbury House

Halfway between Cranbrook and Goudhurst (to the west) is Glassenbury House. This is an exceptionally beautifully situated mansion, built in 1475 for Walter Roberts. This family lived here for centuries, making gradual modifications to their home, including digging a moat. The postcard below shows the front, with ugly Victorian additions, which have subsequently been removed. Wellington's charger at the Battle of Waterloo, Jaffa, is buried in the grounds and marked by a stone pillar memorial. Knight Frank & Rutley advertised this property in recent years for £8 million.

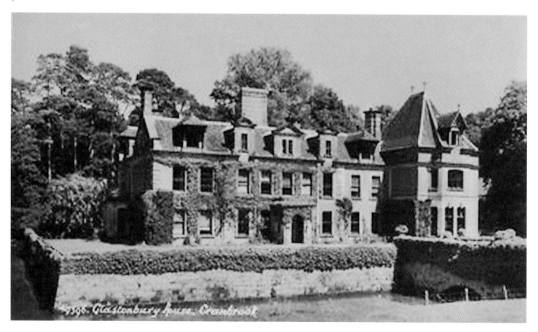

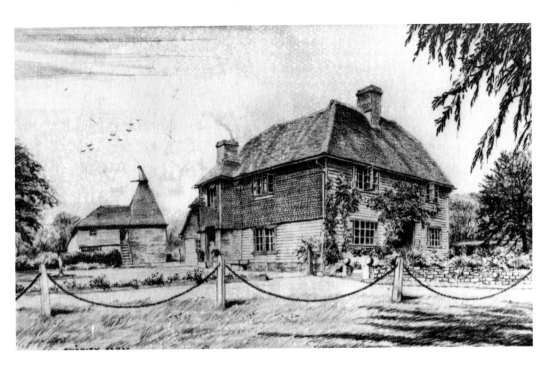

Charity Farm, Cranbrook

In the sketch above, Charity Farm was a typical Kentish farmstead with a cosy farmhouse and oast kiln. Today, a thriving retail business has developed here, selling animal feedstuffs, garden essentials and many other goods.

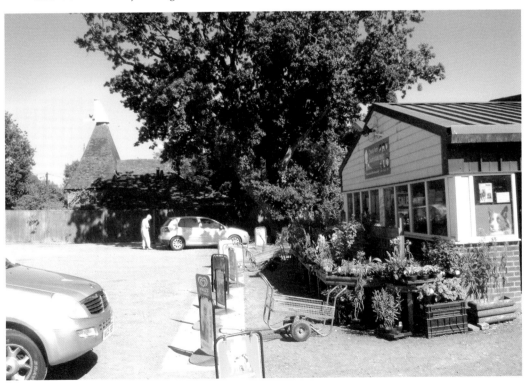

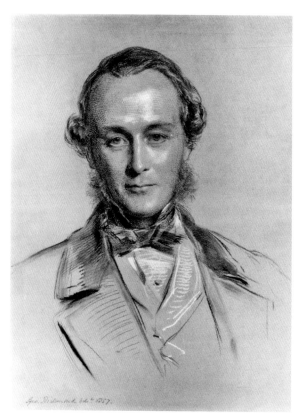

Geo. Richmond delt 1857.

Hempsted House I

Hempsted House was designed by George Devey and built in the neo-James I style for the eminent Conservative politician Viscount Cranbrook in 1859. Later, it was owned by press baron Lord Rothermere, who truncated the strikingly prominent original tower. Since 1924, it has been occupied by Benenden School, a private boarding school for girls, which was attended by the Princess Royal.

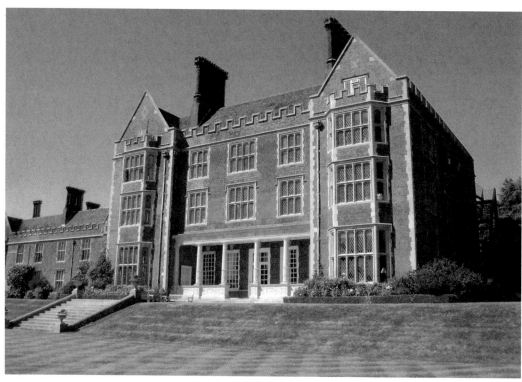

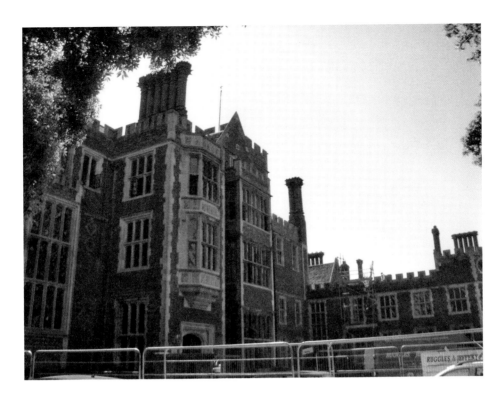

Hempsted House II

Viscount Cranbrook was elevated to the status of earl towards the end of his distinguished career in government, having held many high offices such as Home Secretary, Secretary of State for War and Secretary of the India Office. Near his stately mansion he had a public well created to celebrate the Jubilee of Queen Victoria. His family motto was a play on the words of his Mother's surname, Hardy: *Arme De Foi Hardi* ('armed with hardy faith').

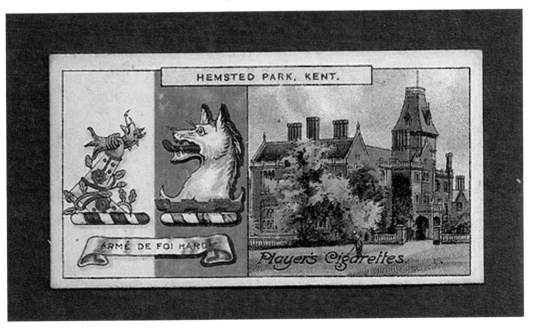

COMPETITION	WINTER PAIRS - BETTER BALL STABLEFORD.												Please indicate which tee used	
DATE 8 NOV 2011	TIME 9.03									Handicap	Strokes Rec'd		PAR 70 SSS 71	
Player A	GEOFF WENMAN									20			PAR 70 SSS 71	
Player B	ALAN COVILL.									20			PAR 70 SSS 71	
Player C													PAR 70 SSS 71	
Player D														

Hole	Marker's Score	White Yards	Par	Yellow Yards	Stroke Index	Score A	Score B	Score C	Score D	NETT +/= POINTS	Ladies Red Yards	PAR	Stroke Index
1		384	4	379	9	5/2	5/2			2	340	4	8
2		402	4	389	7	-	5/2			2	336	4	9
3		163	3	158	14	4/2	4/2			2	158	3	11
4		436	4	425	2	4/2	-			2	351	4	5
5		544	5	534	11	-	5/3			3	481	5	13
6		375	4	364	5	5/2	-			2	310	4	3
7		319	4	295	17	-	4/3			3	283	4	15
8		173	3	165	15	-	1/5			5	146	3	17
9		447	4	428	4	4/1	-			1	388	4	2
OUT		3243	35	3137						22	2793	35	
150 YARD MARKERS TO THE CENTRE OF THE GREEN													
10		345	4	335	12	5/2	-			2	280	4	14
11		148	3	129	18	-	1/5			5	129	3	18
12		540	5	504	8	4/2	4/2			2	462	5	4
13		118	3	116	16	3/3	-			3	109	3	16
14		418	4	406	1	4/2				2	368	4	1
15		374	4	363	6	5/2	5/2			2	317	4	6
16		393	4	360	3	5/2	-			2	303	4	7
17		363	4	347	13	5/2				2	337	4	10
18		372	4	359	10	-	4/3			3	325	4	12
IN		3071	35	2919						23	2630	35	
OUT		3243	35	3137						22	2793	35	
TOTAL		6314	70	6056						45	5423	70	

HANDICAP	
45 STABLEFORD POINTS OR PAR RESULT	NETT

Marker's Signature _A. Adam_ Player's Signature _Geoff_

Hempsted Forest Golf Club

Only founded in 1969, Hempsted Golf Course is one of the finest in Kent. It is unique in having a converted oast house as its clubhouse. Upon its walls hangs the photograph, seen above, of a fortunate player who hit two holes in one during a round on 8 November 2011. The odds on achieving this feat stand at 67 million to one – four times the odds on winning the lottery!

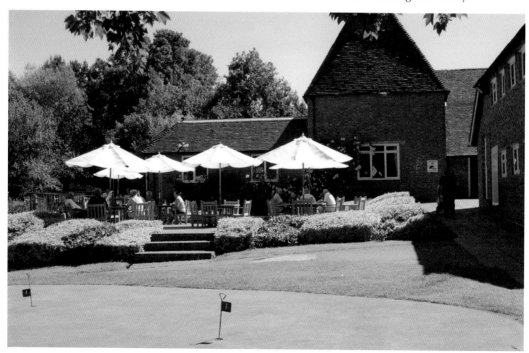

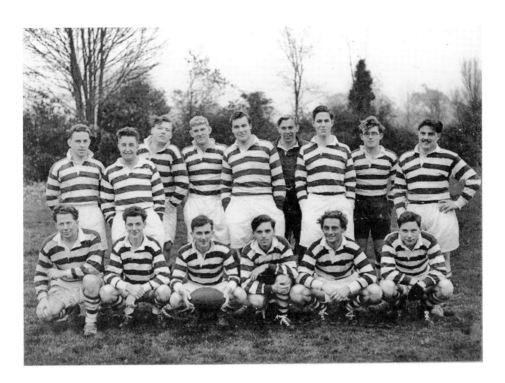

Cranbrook Rugby Club

Cranbrook call themselves 'the biggest, littlest club in Kent'. This soubriquet is accurate, considering its junior side's disproportionate success in Kent leagues compared to much larger town clubs. Currently, apart from these juniors, there are three senior sides and a vet's side, which play regularly. A team photograph of yesteryear is shown above, together with a more recent action shot of players in a match against Beckenham.

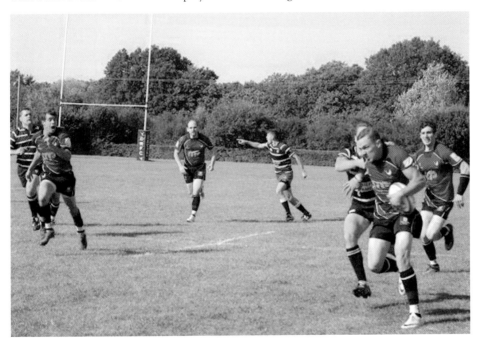

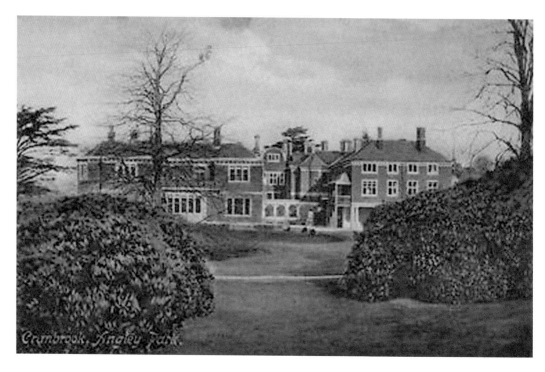

Angley House

The manor of Angley was for many generations owned by the Henley family, until it was purchased by Mr Smart of London in 1785. The mansion is portrayed in many surviving contemporary prints and even postcards of its entrance lodge. Below is a view of its extensive grounds.

'Be All You Can'
Motto of Webster Girls House,
Cranbrook School.

Thomas Clark, a cobbler from Canterbury, composed this tune with help from his friend John
Francis, a schoolmaster from Cranbrook.

Acknowledgements

A great debt of gratitude is primarily owed to my beloved Jocelyn, who, throughout eleven books in this series, has unfailingly and selflessly helped and encouraged me in every way possible. Sincere gratitude is also due to my charming neighbour, Trac, who has provided invaluable computer wizardry with patience and humour. I would also like to thank all those, too many to name, who have given their assistance. Should there be any errors of commission or omission, I would like to apologise and offer to rectify them in a further addition. Lastly, appreciation must be recorded for Roseanne Rogers of Amberley Publishing, whose collaboration, editing skills and forbearance of my inadequacies has ultimately prevailed.